SHE THE
PEOPLE

# SHE THE PEOPLE

A GRAPHIC HISTORY OF
UPRISINGS, BREAKDOWNS,
SETBACKS, REVOLTS, AND
ENDURING HOPE ON
THE UNFINISHED ROAD
TO WOMEN'S EQUALITY

## JEN DEADERICK

ILLUSTRATIONS BY
### RITA SAPUNOR

SEAL
PRESS

Seal Press
Hachette Book Group
1290 Avenue of the Americas, New York, NY 10104
sealpress.com
@sealpress

Printed in the United States of America

First Edition: March 2019

Published by Seal Press, an imprint of Perseus Books, LLC, a subsidiary of Hachette Book Group, Inc. The Seal Press name and logo is a trademark of the Hachette Book Group.

The Hachette Speakers Bureau provides a wide range of authors for speaking events. To find out more, go to www.hachettespeakersbureau.com or call (866) 376-6591.

Print book interior design by Chrissy Kurpeski

Library of Congress Cataloging-in-Publication Data has been applied for.

ISBNs: 978-1-58005-871-1 (paperback), 978-1-58005-872-8 (ebook)

LSC-C

10 9 8 7 6 5 4 3 2 1

*For the two Rosalinds*
*and my mother, Ann, who made sure*
*I knew about Victoria Woodhull*

# CONTENTS

PLUS MORE!

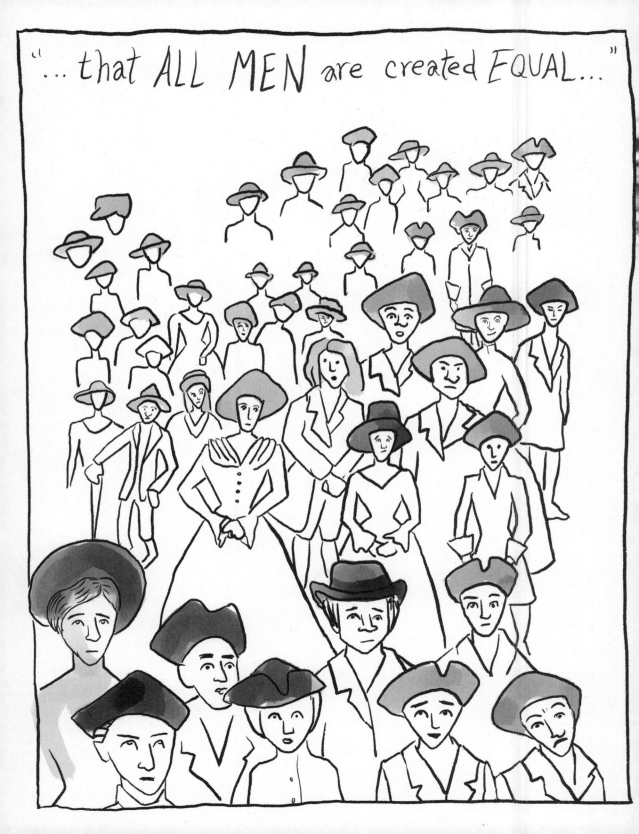

# REMEMBER THE LADIES

## 1776–1864

*THE NEWS OF THE DECLARATION* spread rapidly. Copies of the document had been printed immediately, and riders distributed them all over the colonies. Embarrassingly, an overly enthusiastic patriot in tiny Worcester, Massachusetts, not yet an industrial powerhouse, intercepted a copy en route to Boston and read it aloud to a private crowd, but the event in Boston on July 18, two weeks after the signing, was still special.

THE DECLARATION was read from the balcony of the Town-House, the seat of the Massachusetts colonial government, overlooking the very spot where, just two years earlier, rioters had been shot and killed by British soldiers in what became known as the BOSTON MASSACRE. The Town-House was where the colonial legislature met, and statues of a lion and a unicorn—symbols of the Crown and reminders to the citizens of Boston of whose royal decree they ultimately lived under—adorned its roof. The building sat atop a hill that rolled gently down to the harbor, just a half mile away. After the REVOLUTION, it would be claimed as the State House, the meeting place of the state legislature.

The crowd was mixed. Sailors from around the world mingled with Black and White residents of the city in the bustling markets surrounding the square, though the recent military occupation of the agitated and rebellious city had reduced their number.

And, of course, many of the people in the square that day were women—women are always in all of these stories whether their presence is noted or not. That day, more women than usual came to witness history happening.

ABIGAIL ADAMS, whose husband would later become president, was in the crowd, and described the scene in a letter to her husband a few days later, using the irregular spelling of the day:

> Last Thursday after hearing a very Good Sermon I went with the Multitude into Kings Street to hear the proclamation for independance read and proclamed. Some Field peices with the Train were brought there, the troops appeard under Arms and all the inhabitants assembled there (the small pox prevented many thousand from the Country). When Col. Crafts read from the Belcona of the State House the Proclamation, great attention was given to every word. As soon as he ended, the cry from the Belcona, was God Save our American States and then 3 cheers which rended the air, the Bells rang, the privateers fired, the forts and Batteries, the cannon were discharged, the platoons followed and every face appeard joyfull.

Of course, we know which words kept the crowd rapt: the opening sentences that broadly and assuredly speak of human events and the dissolution of political bonds. The magnificent list of grievances against the king. The pledging of lives, fortune, and sacred honor. Ringing bells and blasting cannons were the only way to follow the reading.

Bostonians, always looking for a good excuse to riot, climbed onto the roof of the Town-House and tore down the symbols of the Crown, the lion and unicorn. Consent of the governed, indeed.

But it's the opening of the second paragraph that changed everything. It's what still rings in our ears more than two centuries later:

> We hold these truths to be self-evident, that all men are created equal, that they are endowed by their Creator with certain unalienable rights, that among these are life, liberty and the pursuit of happiness.

The audacity is astounding. We know it now as a promise still unfulfilled, but for the men of the time to declare that they and all other men were equal to a *king* and were *created* that way was bold as hell. Most people on the planet lived in societies in which some inbred family claimed some cosmic force had decided they should be in charge, and everyone had to go along with it until the monarchs were beheaded. So, pause for a moment and raise your glass to inalienable rights.

THAT BEING SAID . . .

The men who wrote the Declaration of Independence didn't really believe that ALL men were equal. The statement is largely a rhetorical flourish produced by a group that included a fair number of enthusiastic owners of slaves. What they really meant in the Declaration by "all" was landowning White guys like themselves. The "men" part, however, they *totally* meant.

> ## WHAT THEY REALLY MEANT IN THE DECLARATION BY "ALL" WAS LANDOWNING WHITE GUYS LIKE THEMSELVES. THE "MEN" PART, HOWEVER, THEY TOTALLY MEANT.

The colonists spent the next eight years fighting a bloody war of independence against the Crown while debating exactly what this new country would look like. After

> ## CONSTITUTIONS, HOWEVER, ARE JUST SYMBOLIC PIECES OF PAPER IF NO ONE TESTS THEM IN THE COURTS

the initial printing of the Declaration had gone out, the Continental Congress commissioned firebrand Baltimore printer and postmaster **MARY KATHERINE GODDARD** to create a more compelling edition, this one with the signatures attached, giving it a powerful punch.

This copy spread everywhere, and a radical woman's name imprinted at the bottom made the Declaration an even hotter topic of discussion around the colonies. While the War of Independence raged on, the citizens of this country-to-be hammered out how to make states out of colonies.

Massachusetts, always the nerdy overachiever, had a constitution drawn up even before the war was over. The first draft in 1778 was widely rejected, in part because it upheld the institution of slavery and limited the rights of Free Blacks. Another version of the state's constitution that included the words "all men are born free and equal" was introduced, and that one was ratified in 1780.

Constitutions, however, are just symbolic pieces of paper if no one tests them in the courts.

In the early 1780s, **ELIZABETH,** an enslaved woman also known as **MUM BETT,** heard the talk around the dinner tables she served of

men being born free and equal and of certain inalienable rights. Her owners were enthusiastic supporters of the Revolution. One day, the wife, enraged, struck at Elizabeth's younger sister with a hot iron. Elizabeth jumped between them to take the blow and suffered severe burns on her upper arm.

That was it. At the first chance, she walked over to see her neighbor, abolitionist Theodore Sedgewick, and asked him to help her sue for her freedom on the basis of the new Massachusetts constitution. She won her case and gave herself the surname **FREEMAN.** Her case, along with those of others, helped overturn slavery throughout the state, adding Massachusetts to the growing list of Free States.

Before they were states, each colony had its own specific charter detailing its relationship with the king. Though they ultimately answered to the monarch, colonies made their own laws through their legislatures and town meetings. Most of these laws were modeled on English law, which at that point was split between common law and canon law. Common law governed everyday life, primarily in the public sphere, from murder to theft to contracts. Canon governed in matters the church oversaw, like marriage. Women's lives were mostly governed by canon law.

Based on interpretations of the BIBLE by Saint Augustine, Thomas Aquinas, Martin Luther, and others, canon law held very strict distinctions about the roles of women in the world. Women were considered to be pale and imperfect imitations of men, easily corrupted and relentlessly corrupting. As Aquinas put it, "As regards the individual nature, woman is defective and misbegotten."

Early Christian thinkers, which included numerous well-known women, had frequently described Eve as the hero of the Genesis story. As the male-dominated Catholic Church became more and more powerful, its decisions on which writings to include as official scriptural interpretations and as books of the Bible itself solidified a notion that Eve was not only a villain but also the representation of all women. Women, and women with knowledge in particular, were branded as temptresses who led men into trouble if allowed.

This was used over the centuries to justify keeping women out of political and commercial life, or what was known as the public sphere.

> BASED ON INTERPRETATIONS OF THE BIBLE . . . CANON LAW HELD VERY STRICT DISTINCTIONS ABOUT THE ROLES OF WOMEN

> *AS AQUINAS PUT IT, "AS REGARDS THE INDIVIDUAL NATURE, WOMAN IS DEFECTIVE AND MISBEGOTTEN"*

Women instead were given control of the domestic sphere, or their home, but only in a day-to-day sense. The patriarch of the household always had final say.

These strict definitions of spheres only tended to happen in societies with a degree of democracy. In a total monarchy, everyone is ultimately subject to the monarch, so any power to be gained in the public sphere is subject to the monarch's whim.

Once any degree of democracy becomes the political system, however, roles in public life become more official through codes of law and constitutions. At this point, women's lives can become more restricted, as the public sphere is more strictly defined. As power expands to wider circles of people, the people who already have more power tend to want to define that circle as something that includes them, and not outsiders who might threaten their power.

In 1781, the former colonies agreed on the **ARTICLES OF CONFEDERATION,** making their unification official and swapping out the Crown and Parliament for a fairly weak and barebones federal government that primarily taxed and waged war. The states were otherwise left to govern themselves independently. They hoped to preserve a similar kind of autonomy as they had as colonies under the king, when they didn't need to answer to the

THE REALITY
IS THAT PEOPLE
LIKE STABILITY,
AND NEED IT

other colonies in making decisions for themselves.

Wars, however, cost money. A lot of money. The colonists were victorious in the Revolution, but the federal government was left in incredible debt. This was a burden for all the states, particularly the poorer states, and pressure built to formally define the relationships and obligations between the states. On May 25, 1787, the **CONSTITUTIONAL CONVENTION** kicked off in Philadelphia. Four months later, they had a version ready to present to the states. Never forget that the United States was founded in a series of long, tedious, and occasionally acrimonious meetings. As a result, there were a LOT of compromises, some small and relatively benign, some large and horrifying.

The reality is that people like stability, and need it. Revolutions sound glamorous, but they are chaotic, destructive, and deadly. As the Declaration puts it,

> Prudence, indeed, will dictate that Governments long established should not be changed for light and transient causes;

## WARS, HOWEVER, COST MONEY. A LOT OF MONEY

and accordingly all experience hath shewn that mankind are more disposed to suffer, while evils are sufferable than to right themselves by abolishing the forms to which they are accustomed.

The thirteen American colonies were offshoots of England, and less than a century earlier England had gone through a bloody revolution in which the king was beheaded. There was justifiable fear of bringing that sort of violent chaos to American shores. Prudence, indeed.

The Declaration's epic list of the king's repeated abuses and usurpations addressed his overstepping his bounds in matters of governance and the judiciary. All thirteen colonies had complained of these issues, and these grievances bonded them in their desire for independence. The king was in breach of contract with his colonies, and all legal avenues of redress had been tried. The colonies had been left only with revolution.

*THE KING WAS IN BREACH OF CONTRACT WITH HIS COLONIES, AND ALL LEGAL AVENUES OF REDRESS HAD BEEN TRIED. THE COLONIES HAD BEEN LEFT ONLY WITH REVOLUTION.*

On March 31, 1776, during the war, Abigail Adams had begun writing one of her regular letters to her husband, who was then off in Philadelphia debating with other men of the colonies whether it was time to declare independence from Britain. She spoke of the hardships in occupied Boston and her fears of smallpox. Then, in the middle of the letter, almost as an afterthought, she urged that when he and the other men wrote the code of laws that would be necessary in an independent country they **"REMEMBER THE LADIES."** She went on to explain:

Do not put such unlimited power into the hands of the husbands. Remember, all men would be tyrants if they could. If particular care and attention is not paid to the ladies, we are determined to foment a rebellion, and will not hold ourselves bound by any laws in which we have no voice or representation.

That your Sex are Naturally Tyrannical is a Truth so thoroughly established as to admit of no dispute, but such of you as wish to be happy willingly give up the harsh title of Master for the more tender and endearing one of Friend. Why then, not put it out of the power of the vicious and the Lawless to use us with cruelty and indignity with impunity. Men of Sense in all Ages abhor those customs which treat us only as the vassals of your Sex. Regard us then as Beings placed by providence under your protection and in immitation of the Supreem Being make use of that power only for our happiness.

She then put the letter aside and didn't pick it up again until April 5, explaining that she'd been tending to the sick in town and mourning the dead. She concluded without bringing up the ladies again.

As we now know, particular care and attention was not paid to the ladies in the United States Constitution. In fact, Adams laughed her off in his written reply, referring to a potential **"DESPOTISM OF THE PETICOAT."** Abigail complained in a letter to her friend, political satirist **MERCY OTIS WARREN,** "He is very sausy to me. I think I will get you to join me in a petition to Congress." Mercy's reply, likely witty, is lost to us, alas.

**"PETTICOATS"** was often used as shorthand for "women" in the way that "skirts" has been used in more modern times, reducing women to an item of clothing considered frivolous and decorative. Petticoats make women pleasing to the eye but are otherwise inconsequential. They lift things up but aren't essential, and one is like any other. They serve without being seen.

Still, the Constitution starts with the words "We the People"—not "we the White guys," not "we the landowners," not even "we the citizens"—we the PEOPLE of the United States. The idealism of the Dec-

*"PETTICOATS" WAS OFTEN USED AS SHORTHAND FOR "WOMEN" . . . REDUCING WOMEN TO AN ITEM OF CLOTHING CONSIDERED FRIVOLOUS*

*THE IDEALISM OF THE DECLARATION OF INDEPENDENCE INFUSES THE CONSTITUTION'S LISTED OBJECTIVES, THE FIRST OF WHICH IS "TO FORM A MORE PERFECT UNION"*

*WITH MEN QUESTIONING THEIR RIGHTS AND THEIR ROLES IN SOCIETY, LOTS OF WOMEN HAD, TOO.*

laration of Independence infuses the Constitution's listed objectives, the first of which is "to form a more perfect union." Though this has an idealistic ring, it also speaks to the difficulties the colonists encountered in uniting the disparate states after the Revolution.

While the slave-owning signers hold a greater responsibility, the non-slave-holding creators of the Constitution were willing to live with slavery's existence. None of them seriously considered including women in this democracy. When **MARY WOLLSTONECRAFT,** the prominent English writer and philosopher, published her widely read *A Vindication of the Rights of Women* in 1792, she similarly could not make the leap to stating women should be full citizens, saying only that they were capable of rational thought, which was considered radical enough—what would Thomas Aquinas say?—and asking only that women be allowed education.

Wollstonecraft's questioning of the role of women didn't come out of nowhere. With men questioning their rights and their roles in society, lots of women had, too. The

# "... IT IS A COMPARISON OF AMAZONS TO ANGELS."

Revolution itself spurred a lot of questioning in the United States about to what extent old laws had to be preserved, particularly the canon laws. A break with the Crown meant a break with the Church of England. People started getting married less and worried less about premarital sex and having children within the confines of marriage. Freedom broke out all over the place.

THOMAS JEFFERSON had spent time in France before the FRENCH REVOLUTION and came to share the views of ROUSSEAU and others, that uppity women and their salons had helped cause all the trouble. He envisioned a stronger barrier between the public and domestic spheres in the United States. "Our good ladies, I trust, have been too wise to wrinkle their foreheads with politics. They are contented to soothe and calm the minds of their husbands returning from political debate. . . . It is a comparison of Amazons to Angels."

In a nutshell, women scared the crap out of Jefferson.

He sought to codify, and thus justify, the divisions between men and women that he believed to be essential. Consider him a perfect personification of the combination of high ideals and loathsome compromise that founded this country.

When his wife died, Jefferson chose as a companion a girl he owned: **SALLY HEMINGS,** a young slave who was herself a product of the sexual exploitation of another enslaved woman by Jefferson's late wife's father. Sally was Jefferson's late wife's half-sister.

Sally Hemings was sixteen when Thomas Jefferson, forty-four, first had sex with her. They were in Paris at the time, and slavery was illegal in France, so she was technically free. Imagine for a moment her options.

Yes, she could have in theory refused to allow this man to have sex with her, but what might the repercussions have been? Would she have been beaten? Cast out onto the streets of Paris to make her way in a breadless city on the verge of a violent revolution where people of color were required to carry identification papers? Jefferson was careful never to let on that she or the other enslaved people with him were enslaved, conscious of his reputation as the author of the Declaration of Independence. It would have been assumed that she was a servant, in a country where servants had few rights.

As the companion of a rich and educated White girl—**POLLY JEFFERSON,** Thomas Jefferson's daughter, and her niece—Hemings had become somewhat educated herself

## IN A NUTSHELL, WOMEN SCARED THE CRAP OUT OF JEFFERSON.

and accustomed to the privileges her position afforded her. Did she think about **PHILLIS WHEATLEY,** the celebrated African American poet of the American Revolution who had died just a few years before, penniless, grieving three dead babies, her husband in debtor's prison, all painfully soon after she was granted her freedom? Though Hemings had traveled only between two plantations in Virginia, with no other experience of the world, her older brothers had traveled extensively in service to Jefferson, including to Boston. Had they heard talk of the brutal end to the life of an educated Black woman whose laudatory poems had made her a celebrated and protected figure among the White people who owned her?

In Virginia, Free Blacks were thought to inspire enslaved people to revolt, so a freed enslaved person was required to leave the state within six months of manumission. Sally made the difficult choice—as much as it was a choice—to stay with Jefferson, ultimately returning to Virginia with him after he promised that their children would be set free upon his death. Meaning she would never see them again.

The body of an enslaved person legally and completely belonged to the slave owner, and that included her breasts, vagina, and uterus. Babies born to enslaved mothers were automatically considered to be enslaved themselves. Sally Hemings, knowing that the much older Jefferson would likely die before she did, and assuming that her enslavement would continue after his death, was willing to trade her own freedom for a future in which she might never see her children again—but a future in which they would be free.

Enslaved women weren't allowed to hold on to their families. They weren't allowed to officially marry. They couldn't hold on to their parents or siblings or, often most agonizing, their children. **HARRIET TUBMAN** had to leave behind her husband when she escaped to freedom. He was justifiably terrified of getting caught. She couldn't bear not to try. As we know, she not only made it but also went back for more enslaved people. The first few she went back for were her brothers.

The abolition movement used the image of children being torn from their mothers' arms in pamphlets and newspapers to illustrate slavery's horrors. It was the identification with the feelings of those mothers that brought many White women to the cause, and they were some of its most stalwart activists. Many future suffragists gained their organiz-

> *ENSLAVED WOMEN WEREN'T ALLOWED TO HOLD ON TO THEIR FAMILIES. THEY WEREN'T ALLOWED TO OFFICIALLY MARRY. THEY COULDN'T HOLD ON TO THEIR PARENTS OR SIBLINGS OR, OFTEN MOST AGONIZING, THEIR CHILDREN.*

> *MANY FUTURE SUFFRAGISTS GAINED THEIR ORGANIZING AND PROTESTING SKILLS IN THE ABOLITIONIST MOVEMENT*

ing and protesting skills in the abolitionist movement.

In 1820, Missouri became a state. The residents of the territory were dead-set on owning slaves, but this would mean there would be one more slave state than Free State in the country. Representatives of the existing Free States were adamantly opposed to this possible imbalance, and so another one of those compromises was worked out. In exchange for Missouri's becoming a state, a cold and rocky but delightful area in the Northeast that was considered part of Massachusetts would become an independent Free State: Maine. As part of the compromise, a line was drawn across the states between the North and South delineating where slavery was allowed and where it was not.

The slave states didn't want balance. They wanted domination. Frustrated that the Free States had become safe havens for enslaved people who ran away from their owners, in 1850, the slave states pushed through the **FUGITIVE SLAVE ACT.** Not only did the act give federal agents the authority to capture Black people living in Free States and transport them to the custody of those who claimed to own them, it required that the agents do so.

Soon, Black people, some of whom had never been enslaved at all, were being rounded up in every Free State. Activist opponents of slavery were vigorously opposed to the Fugitive Slave Act before it became law. Once it took effect, even those in Free States

who didn't particularly like the idea of slavery, but who were willing to let it exist in the slave states and to accept the economic benefits, were moved to anger and action. Aside from the horrors of slavery itself, the act was seen as an outrageous overreach by the slave states, upholding slavery by infringing on the rights of the Free States. There were riots in some places when agents attempted to capture Black people, with White people fighting back, too. The Free North's tolerance of the Slave South and its "peculiar institution," as it was known euphemistically, was being pushed to a breaking point.

In 1855, **CELIA,** an enslaved woman, killed her owner after five years of being raped and otherwise sexually assaulted by him. Her owner was in his seventies when he purchased her; she was fourteen. She had two children by him before she killed him.

Rape was illegal in the state of Missouri, but, as was true throughout the country, the restrictions on rape were based in the rights of men—fathers, brothers, and husbands—over the female body. The physical, mental, and emotional trauma to a woman was not the concern. The rape of a woman brought shame upon her family, and made her undesirable in the marriage market, and that was the primary focus of the laws against it.

When a married woman was raped, legally the act was considered an offense against her husband, who had sole rights to her body. Women gave up most of their

> *THE SLAVE STATES DIDN'T WANT BALANCE. THEY WANTED DOMINATION.*

rights when they married. All of their property and any children they produced belonged to her husband. Husbands could legally beat their wives, though some states had laws governing the thickness of the stick they could use (in Massachusetts, for instance, a man wasn't allowed to beat his wife with a stick any thicker than his thumb, the basis for the expression "rule of thumb"). Husbands also retained full rights to have sexual relations with their wives whenever they desired. Wives could not legally refuse.

## WHILE WHITE WOMEN WERE BEING FORCED INTO THE DOMESTIC SPHERE, ENSLAVED BLACK WOMEN WEREN'T ALLOWED TO HAVE ONE

In 1855, twenty-nine years after Jefferson's death, Missouri—a state so determined to be a slave state when it was founded that a whole other state had to be carved out to balance the vote in Congress—defended the slaveowner's dominion. A judge and jury found, in a decision ultimately upheld by the state's Supreme Court, that Celia had no legal right to defend herself against the man who owned her because her entire body was his property, and she had no rights over it.

This essentially gave her owner the rights of a husband, though Celia had never had the option to refuse to enter into this legal relationship. Also, enslaved people were not allowed to be legally married because it would complicate the dominion of an owner over enslaved women he owned if those women had husbands, who also could claim dominion. Enslaved men, however, were not allowed to have dominion over anything, especially enslaved women. The state waited for Celia, pregnant at the time of her conviction, to give birth to her third child—stillborn, as it turned out—before she was hung by the neck until she died. The horror of this ruling made it clear how awful the compromise that allowed Missouri to be admitted as a slave state, expanding slavery itself.

So, while White women were being forced into the domestic sphere, enslaved Black women weren't allowed to have one. If they weren't working in the field, they were tending to the domestic spheres of other people. Who they were as humans, and as women specifically, in relationship to this reality was something they would spend decades working out on their own.

THE AGE OF ENLIGHTENMENT, a time of amazing scientific exploration, heavily influenced the thinking of the leaders of the new America. As the scientific method developed, a focus on minute categorization became essential to the experiments being conducted. Things can't be explained if we don't have names for them. Carbon is carbon, helium is helium, and so on, and knowing that water is two parts hydrogen and one part oxygen, and never any other combination, is important. This systematic thinking seemed to require strict classifications of masculine and feminine, male and female, man and woman.

Yet people are not simply physical components cobbled together. Every human being is a complex combination of elements that form molecules that form blood and skin and sweat and muscles. Our bodies grow and change according to instructions written in our DNA and the elements we take in from the food we eat and the air we breathe. Our minds are shaped by our bodies and by everything we're exposed to in the course of a lifetime, from the people eliciting our language through coos and repetition to YouTubers teaching us how to make chicken in an Instant Pot.

In scientific theory, everything must be looked at dispassionately and questioned, but the people with the means, education, and leisure time to conduct scientific experiments were by and large rich White men. This had a serious impact on which questions they asked. As a result, lots of time and effort went into finding and publishing scientific "proof" that the human world was organized the way it was because that was naturally how things should be. Every classification system rich White men created put them up at the top of the heap, so the ideal societies they aimed for did the same. Utopias tend to reflect the desires of those who create them.

This is another way in which constitutions formalize the public sphere, making it central to everyday life. Under a monarchy, everyone is kind of equally powerless in their subservient role to the Crown and nobility. Democracy creates layers of citizens, some more empowered than others.

## DEMOCRACY CREATES LAYERS OF CITIZENS, SOME MORE EMPOWERED THAN OTHERS

Jefferson spoke often of how distasteful he found the public sphere, though he thrived in it. He envisioned a world in which wise men spent their days in bucolic settings, overseeing the happy workers tending to their lands and homes, welcomed into their parlors by smiling and comforting wives.

A few decades later, **MARGARET FULLER** began to question in writing this limited role for women. She saw herself in the great action heroes of literature. While her fellow **TRANSCENDENTALISTS** sought to transcend the earthly plain through contact with remote nature, she, a rare woman in the bunch, saw transcendence in engaging with the messiness of human beings.

Though she fought the restrictions, she longed to get married, the only way a proper woman was allowed to be sexual. Unconventional in her looks, and smarter than most men, it wasn't until she went to Italy that she found a husband. She and the young man had a baby together, and were blissfully happy. Then they were all killed in a shipwreck in Maine in a ridiculously cruel end. Yep. Depressing as hell.

Actual farm girls, women Jefferson might have imagined embracing his vision, began to be drawn to other work and different lives, too. Women traditionally did fabric work in the home before the **INDUSTRIAL REVOLUTION,** so they were considered the natural population to do it in factories. Also, young, unmarried women were free-floating. While the young men were farming, young women were waiting to marry them. It was a liminal time, undefined, in their lives. Modern textile mills gave them a chance to make a little money for themselves and their families. They worked for a few years, then got married or moved on to a better job.

On a visit to Massachusetts, newly reelected President Andrew Jackson—a man who had built a wide back porch off the sec-

ond floor of his Nashville plantation house so he could gaze upon his slaves' cabins from on high, like a benevolent father, and see that everything was in order—visited these modern textile mills and loved that the mill girls lined the streets in matching white dresses so he could look upon them as he rode by in his carriage. They would be the "wives of virtuous, high-minded, independent citizens," he was told by the men who ran the factories, a reassurance that these were not ruined women.

**THE LOWELL MILLS,** a series of textile mills in Lowell, Massachusetts, were founded as an improved version of the notoriously unsafe and dismal factories of England. Large windows let light in, and state-of-the-art ventilation systems maintained air quality. But that didn't make them easy places to work.

Most mill girls had grown up on farms, so they were used to hard work, but the factories were particularly tough. They worked seventy hours a week in shifts that went from four thirty in the morning to seven thirty at night. As single women, they couldn't live on their own, so they mostly lived in unsanitary and crowded company-owned boarding houses, bunking four to eight per room. Hundreds died from tuberculosis, typhus, dysentery, and cholera.

Still, there were great benefits. Many were thrilled by the independence they had so far from home and with their own money in their pocket. Beyond that, there was the community. The overseers and managers were men, but otherwise theirs was a society of women. They not only lived, worked, and ate together but also attended concerts and lectures to-

## THE OVERSEERS AND MANAGERS WERE MEN, BUT OTHERWISE THEIRS WAS A SOCIETY OF WOMEN

gether. Steam-powered trains meant they could visit Boston on their day off.

They also talked. It was rare that so many women, free from the domestic sphere, could get together and talk. Then they started writing. Their newspaper, the *Lowell Offering,* is now legendary for its poems and stories and essays. They found their voices with each other, and then used them to advocate for themselves and their sisters.

Their fathers and grandfathers had fought in the Revolution, and the mill girls summoned their spirit in their writing. When they decided they'd had enough of their grim working conditions, they began to organize. In their first petition, they opened with words evoking their forebears:

> We circulate this paper, wishing to obtain the names of all who imbibe the spirit of our patriotic ancestors, who preferred privation to bondage and parted with all that renders life desirable—and even life itself—to produce independence for their children.

They were a huge hit. Steam-powered printing presses had made the printing process cheap and fast. Newspapers, normally media for the WASP-y elite classes, with a select few going for a nickel apiece, proliferated in cities across the country, sold for a

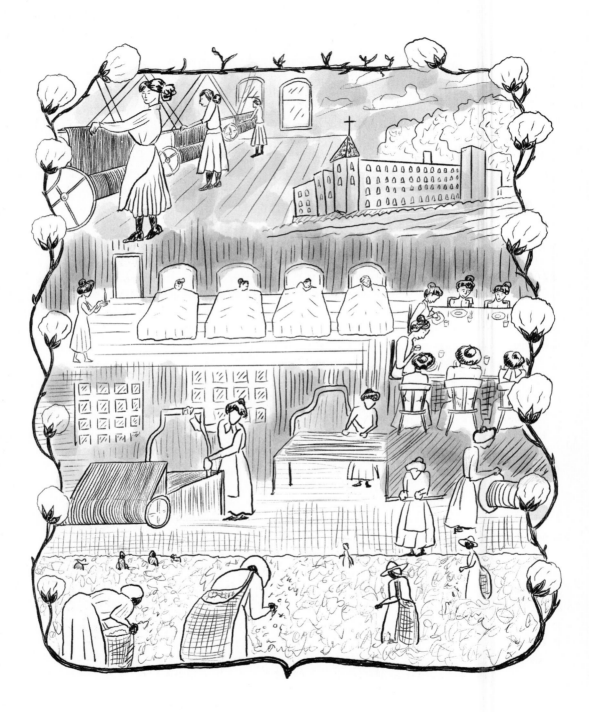

penny each, and targeted niche markets: immigrants, the urban working class, factory workers. The *Penny Press,* as it was called, was always looking for content, and the Lowell mill girls—patriotic, scrappy, wholesome, independent—made for great copy.

In the end, basically none of their workplace demands were met, and the mill girls were eventually replaced by desperate immigrants from famine-ravaged Ireland. Still, their writings lived on and continued to inspire and provoke.

Years later, in the lead-up to the Civil War, **LUCY LARCOM,** one of the leaders of the mill girls, and one of their finest writers, acknowledged the paradox at the heart of their progress. Their taste of financial independence had been propped up by the forced, unpaid labor of enslaved African Americans in the South. She addressed it in her brutally honest poem "Weaving":

> *And how much of your wrong is mine,*
> *Dark women slaving at the South?*
> *Of your stolen grapes I quaff the wine;*
> *The bread you starve for fills my mouth:*
> *The beam unwinds, but every thread*
> *With blood of strangled souls is red.*

That bloody thread ran through the whole fabric of the United States.

In 1848, **LUCRETIA MOTT** and **ELIZABETH CADY STANTON** organized the **SENECA FALLS CONVENTION,** the first women's rights convention held in the United States. They had realized the need for it in London in 1840, when, despite their extensive work on the cause, they had been barred from the floor of the World Anti-Slavery Convention because they were women. Though they continued their abolitionist work in spite of the slight, they realized they needed to organize some conventions for themselves.

On July 19, two hundred women gathered in **WESLEYAN CHAPEL** in Seneca Falls, where they heard Stanton's first public reading of her *Declaration of Sentiments,* deliberately modeled after the Declaration of Independence.

When, in the course of human events, it becomes necessary for one portion of the family of man to assume among the people of the earth a position different from that which they have hitherto occupied, but one to which the laws of nature and of nature's God entitle them, a decent respect to the opinions of mankind requires that they should declare the causes that impel them to such a course.

We hold these truths to be self-evident; that all men and women are created equal. . . .

WE HOLD THESE TRUTHS TO BE SELF-EVIDENT; THAT ALL MEN *AND WOMEN* ARE CREATED EQUAL

With a list of "repeated injuries and usurpations on the part of man toward woman" that included "he has made her, if married, in the eye of the law, civilly dead" and "he has withheld from her rights which are given to the most ignorant and degraded men—both natives and foreigners," it packed a hell of a punch. Its later call for voting rights was revolutionary—though it should have been expected after the vast expansion of voting rights for White men during the Jackson administration.

Still, calling for the right of direct representation was a major leap from **MARY WOLLSTONECRAFT,** whose 1792 *Vindication of the Rights of Women* had merely asked that women be considered as fully human and deserving of education.

It was also a step beyond **MARIA STEWART,** who in her "Mrs. Stewart's Farewell Address to Her Friends in the City of Boston" at the African Meeting House in 1833 had argued for the propriety of women speaking in public. A Free Black woman, she had been pelted with rotten tomatoes for daring to challenge men in her public speeches against slavery. In her farewell address, she discussed the importance of challenging injustice publicly, then asked, "What if I am a woman?"

It is a question that works on so many levels. Her intended meaning—asking what her role in the public sphere should be as a woman—is the central question of this book. Another meaning, however, can be understood as a question asked by an African American woman: What if I am also a woman, just like a White woman? The found-

"WHAT IF I AM A WOMAN?"

ing of this country as a nation that allowed slavery while preaching equality means that the question of who counts as a woman must be asked over and over again, even while we debate what being a woman means.

Three years later, in 1851, **SOJOURNER TRUTH,** an African American evangelist, abolitionist, women's rights activist, and author who escaped to freedom from slavery in 1826, famously asked a similar question in a speech detailing the unladylike reality of her daily life: "Ain't I a Woman?"

Except that she didn't really ask *that* question—not in those words. Sojourner Truth had been born enslaved in the North, owned and surrounded by Dutch people. She never spoke in a Southern Black patois. The speech was written up several years after she gave it by a White woman who thought she remembered Truth speaking that way or who perhaps thought it made Truth sound more like what enslaved women were supposed to sound like. Truth was no longer around to tell her own story and had never written it down herself.

Similarly, the **LEWIS AND CLARK EXPEDITION** should rightly have been called the

Sacagawea Expedition. **SACAGAWEA** knew the land the party was exploring and guided them through it with a baby on her back the whole time. But Lewis and Clark were the ones who wrote down the story, so they got the naming rights.

As European settlers crept deeper and deeper into tribal lands, violently expelling the Natives as they proceeded, the country expanded, bringing the question of slavery to the forefront every time a new state or territory was added. The **MISSOURI COMPROMISE** had evened things in Congress but brought the country no closer to actually resolving the issue of slavery.

Compromise between Free States and slave states no longer seemed possible.

In 1856, **CHARLES SUMNER**, the radical senator from Massachusetts, a passionate and committed abolitionist, made an anti-slavery speech on the floor of the Senate, calling out slave-supporting senators by name. **PRESTON BROOKS**, a US representative from South Carolina, *loved* slavery and was offended on behalf of these vilified senators. Not considering Sumner honorable enough to duel, Brooks attacked Sumner when he was alone in the Senate chamber, beating him severely with a cane, like you would a dog. Or a slave.

Sumner survived, but was left with a painful limp. The House made an unsuccessful attempt to censure Brooks. He resigned, but, considered a hero by the pro-slavery voting White men of his South Carolina district, he was reelected. He died a year later.

Sumner lived another eighteen years to witness the bloody, painful, and imperfect end to slavery. The horrific compromise the authors of the Constitution made in 1789 when they allowed slavery to be upheld in a document that purported to stand for freedom and equality was shown to be untenable. As the federal government gained strength and expanded, and as the slave states demanded more and more concessions to their inflexibility concerning slavery, the idea that the states could coexist as fully independent legal entities came to look ridiculous. The Fugitive Slave Act decisively showed that the slave states only wanted state rights to matter when they upheld their Slave Codes.

The election of Lincoln in 1860 was the last straw. Though he was no radical, Lincoln insisted that slavery could not continue forever in the United States and must be dismantled over time. The South, starting with South Carolina, seceded soon after he took office, and Lincoln would spend his entire presidency waging war against it.

He ultimately signed the **EMANCIPATION PROCLAMATION**, ending slavery in the United States, and helped pass the **FOURTEENTH AMENDMENT**, which guaranteed citizenship to anyone born on US soil—though not FULL citizenship to EVERYONE, but we'll get to that later—after the **THIRTEENTH AMENDMENT**, which had officially outlawed slavery in the United States.

The decades after the Civil War would test whether those amendments meant anything tangible or were just words on paper.

For women, the return to peace meant a return to the work that had begun in Seneca Falls, and Sumner, an advocate for the advancement of women's rights, ended up tangentially connected to that work. Soon after his death, in 1874, Boston held a design competition for a statue of Sumner to be installed on Boston Common. The models were submitted anonymously, so the members of the **BOSTON ART COMMITTEE** were scandalized to discover that the winning model had been submitted by a woman. ***ANNE WHITNEY*** had sculpted a man's trousers! Her hands had worked in areas they had no business being!

The sculpting gig was given to the man who came in second. Whitney's sculpture wasn't cast until 1911, after she'd sculpted a number of the magnificent women who would chip away at the domestic sphere and shape the decades to come.

# CHAPTER 2

# MALE CITIZENS

## 1865–1919

**BEFORE WE DISCUSS** anything else, it must be made extremely clear that the Southern states seceded from the Union and fought the Civil War specifically to preserve slavery. Period. Justifications were tacked on to try to make it look like more than that, but the documents of the Confederates are very explicit about their cause. They were fighting to preserve slavery and, even more than that, to preserve White supremacy. They were pretty transparent about that, too, as this excerpt from Mississippi's secession declaration shows:

*Our position is thoroughly identified with the institution of slavery—the greatest material interest of the world. Its labor supplies the product which constitutes by far the largest and most important portions of commerce of the earth. These products are peculiar to the climate verging on the tropical regions, and by an imperious law of nature, none but the black race can bear exposure to the tropical sun. These products have become necessities of the world, and a blow at slavery is a blow at commerce and civilization.*

It is essential to understand this fact in order to understand the efforts the South made to preserve all the vestiges of slavery that it could after losing the war without officially crossing the line set out by the **THIRTEENTH AMENDMENT.**

The Thirteenth Amendment, ratified at the tail end of the war, officially outlawed slavery and indentured servitude in the United States. The **FOURTEENTH** and **FIFTEENTH AMENDMENTS,** also quickly ratified, expanded on the theme, with the Fourteenth guaranteeing citizenship to anyone born in the United States or its territories.

Unfortunately, the Fourteenth went on to specify that one right in particular, the right to vote, was guaranteed only to **"MALE CITIZENS."** This was a direct reaction to the recently begun women's suffrage movement, and pushed it a huge step backward. Before the "male citizens" clause, no mention of gender

or sex was made in the Constitution, leaving its interpretation open when questions on those topics reached the courts. The Fourteenth Amendment could have been a basis on which to overturn sex-based voting restrictions across the country, but the "male citizens" clause officially codified the second-class nature of women's citizenship.

This is a good spot to talk briefly about *sex* versus *gender* and how they're meant. To sketch things out generally, *gender* usually refers to the role one plays in society, which in a society with strictly defined gender roles is extremely significant. The word *sex* tends to refer to physical attributes: where hair grows on a person's body, what their chest looks like, the shape of their genitalia.

Although it might seem like a recent discussion, human beings have actually always debated how related to physical "sex" attributes gender is. Lots of effort was put into making people conform gender-wise to whatever was between their legs and according to however that gender was meant to act at any given time.

The reality is that gender roles are constructed. At the same time, the hormones rushing through our bodies and the experiences we have with people's reactions to who they think we are and should be based on how we look do have an impact on who we become and how we act.

What we know for sure now is that sex and gender are complicated and fluid concepts, and that the more we

> THE REALITY IS THAT GENDER ROLES ARE CONSTRUCTED

discuss and explore and leave ourselves open, the better off we are.

That, then, was the biggest problem with assigning specific rights only to "male citizens" in the Constitution. Here again was a codifying of society's unequal divisions in the document that defines our nation. It raised the wall around the public sphere a little higher.

Passage of the amendment caused a rift in the suffrage movement between suffragists. Many had supported the amendment despite the "male citizens" clause because it corrected the greater wrong of slavery. Others felt betrayed by the abolitionist movement, which had relied so heavily on the work of women then allowed for them not to be granted voting rights. In her anger, Elizabeth Cady Stanton wrote truly vile, racist things that continue to be a stain on her otherwise astounding career. FREDERICK DOUGLASS, who had long been an ally to the suffragists, said he was fine with Black women speaking through their husbands' votes as White women had done, thereby minimizing the importance of the suffragist movement. This historical moment is a prime example of disenfranchised groups being set against each other to fight for rights, battling it out over a single cookie while the powerful scarfed down the whole plate.

Some of the legal gains early feminists had made had been rolled back during the CIVIL WAR while attention was on the battlefields. It was thought unseemly to ask the federal government to focus on anything other than defeating the Confederates. With

his assassination coming just days after Lee's surrender, Lincoln never got a chance to focus on anything other than the war. So, not only had the now-divided suffragists missed getting the vote, but they were also a couple of steps back from where they'd been.

MEANWHILE . . .

**ANDREW JOHNSON,** Lincoln's successor, had been picked by Lincoln for the vice presidency because he was a pro-slavery Southerner who had nonetheless remained loyal to the Union. This perceived neutrality had made him an inoffensive pick as second banana. He was no radical.

**BENJAMIN WADE,** a senator from Ohio, on the other hand, was a radical. He was one of the major antislavery firebrands in the Senate before and during the Civil War. Among his other radical beliefs was the thought that women should have the right to vote. He became the presiding officer of the Senate when the Fortieth Congress was seated in 1867.

President Johnson had no vice president, so this made Wade the next in line to the presidency. When Johnson was impeached for removing from office the pro-Reconstruction secretary of war who had carried over from Lincoln's presidency, which had been expressly forbidden by Congress, fears of the radical Wade becoming president swayed enough votes that Johnson avoided conviction by one. There was no enthusiasm for radicalism among the elites after the upheaval of the bloody war.

"LIFTING AS WE CLIMB"

Newly free Black women, in the meantime, were exploring what it was to live as free people and who they were going to be as citizens. During **RECONSTRUCTION,** they had space to do that. Black men were stepping forward to vote, run for office, build businesses, and otherwise gain a foothold in municipal life. These attempts at making further progress were often met with violent resistance from White people.

Black women couldn't vote or hold office, but they did begin to organize civic groups to build and assist their communities and to demonstrate to a doubting world that they were respectable and responsible. The slogan of the **NATIONAL ASSOCIATION OF COLORED WOMEN'S CLUBS, INC.,** founded in 1896 as an umbrella group for local and regional Black women's organizations, is still "Lifting as We Climb," a truly perfect motto.

These groups often focused on achieving voting rights for women as well, while at the same time they had to fight to ensure Black men could access their right to vote even

as White people, who still held most of the power, had begun to erect restrictions.

President Johnson was deeply, profoundly, and enthusiastically racist. In one letter to a colleague he wrote, "This is a country for white men, and by God, as long as I am president, it shall be a government for white men." He sympathized with the Southerners, who were appalled at having to share public spaces with Black people and suffer perceived impudence. He assisted them in dismantling the progress made for Black people during RECONSTRUCTION, withdrawing troops that had been sent to protect Black citizens from White citizens who wished to push them as far back into subjugation as possible.

The president encouraged the creation of BLACK CODES, sets of laws that governed allowed behavior for Black citizens. He was also enthusiastic about the creation of the KU KLUX KLAN, organized as a clandestine force that through violence and terror would keep Black people scared and unsure of their rights. With anonymous members under hoods, the Klan was able to operate with no accountability to the law. Believing they were simply gentlemen resorting to desperate measures in desperate times, Klan members claimed an overarching concern to protect White women and their virtue as their noble motivation.

Meanwhile, the White women of the women's suffrage movement still suffered from the major split caused by the divided opinion over

*EVERYONE IS SHAPED BY THEIR SOCIETY, AND EFFORTS HAD TO BE MADE TO UNLEARN APPALLING BELIEFS*

the Fourteenth Amendment. *LUCY STONE* and *JULIA WARD HOWE,* who had supported the amendment, founded the AMERICAN WOMAN SUFFRAGE ASSOCIATION. *SUSAN B. ANTHONY* and Elizabeth Cady Stanton, who had opposed the amendment because of its restriction on women's suffrage, founded the NATIONAL WOMAN SUFFRAGE ASSOCIATION. Each group published its own paper.

Anthony and Stanton at one time were close with Frederick Douglass, who was as passionate an advocate for women's rights as they had been passionate advocates for abolition. The division of the Progressive movement by the use of those two words—"male citizens"—in the Fourteenth Amendment diluted the movement's power at a moment when full strength was sorely needed. At the same time, it pointed up the difficulties of working to expand the rights of more than one group at a time when progress was only really achieved group by group. Douglass cared about advancing women's rights but ultimately did not believe the issue to be as important as freeing his enslaved brethren.

It also goes without saying that adhering to abolitionist politics didn't necessarily mean a person wasn't racist. It was possible to believe Black people shouldn't be enslaved without believing that they were capable of being full citizens, or even that they were fully human. Certainly, everyone is shaped by their society, and efforts had to be made to unlearn appalling beliefs.

None of that is to excuse Elizabeth Cady Stanton's offensive comments. As with Jefferson, who wrote the words that inspired her *Declaration of Sentiments*, we have to look objectively at Stanton and weigh the inspiring things she did against the despicable things she said. This should be a regular task when studying history.

After the war, the most dire issues for women were ownership and inheritance. Over six hundred thousand soldiers had died in the war. Though a handful of women in disguise had served, the lives lost were primarily men's. The total US population was around 31 million. Presuming that men made up just under half the population, war casualties made up a loss of about one-twenty-fifth of the male population, leaving a huge number of women without potential husbands at a time when husbands were essential to a woman's economic stability.

**WAR WIDOWS** are an appealing group of women. A woman who couldn't find a husband might have been viewed as at fault in some way—flawed somehow or too picky. A woman who chose to live on her own was viewed as a harlot or a dangerous threat to the norm. A war widow, however, was blameless and noble, an example of the sac-

## AFTER THE WAR, THE MOST DIRE ISSUES FOR WOMEN WERE OWNERSHIP AND INHERITANCE

## A WAR WIDOW, HOWEVER, WAS BLAMELESS AND NOBLE, AN EXAMPLE OF THE SACRIFICE A DECENT WOMAN WOULD MAKE FOR HER COUNTRY

rifice a decent woman would make for her country.

In 1862, near the start of the war, the Union began providing war widows with small pensions. These became larger pensions as the war went on and lures were needed to bring more men in to fight. Men who were injured fighting were also given pensions, an acknowledgment that they would have a harder time making a living and supporting their wives and children as a result of their service. This, of course, was a nod to the difficulty a woman would have finding work that could support a family, which left the burden on a man's income.

Former Confederate soldiers were not initially eligible for pensions from the federal government, so local collections were taken up, and aid was organized by the women's groups that had supported the soldiers during the war. In 1894, some decades after the war, these ladies' groups would join to form the **UNITED DAUGHTERS OF THE CONFEDERACY**, an organization that eventually became a major force behind the spread of the dangerous, romanticized nonsense of the Lost Cause narrative, which we'll get to later.

Former Confederate soldiers became eligible for federal pensions if they were willing to

submit a formal apology and an oath of allegiance to the US War Department. Eligibility also spread to anyone who had served, not just those who were injured, as the country came to grips with how profoundly the war had affected the population.

In the decades after the war, aging veterans found it more difficult to live with old battle wounds. Sympathetic popular pressure drove massive increases in the pensions. By the 1890s, the US government was spending more than 40 percent of its revenue on Civil War pensions. The pensions became large enough that nineteen-year-old women were marrying—or, more accurately, being married off to—elderly veterans for their pensions even into the 1930s. A Confederate widow died in 2008, and she may not have even been the last one living at that point.

Of course, women had also served on the front lines and were traumatized and often injured. Most notable was ***HARRIET TUBMAN,***

who had served as a nurse and a cook and who recruited and coordinated groups of formally enslaved spies to search out Confederate camps.

Hundreds of women had served as nurses for the Union Army, but they weren't considered when pensions were being handed out. This angered **ANNIE TURNER WITTENMYER,** who had spent the war visiting military hospitals as a representative for aid societies in her home state of Iowa. She knew the rough conditions in which the nurses had worked, and the hours they had put in, and felt that should be recognized. It took a few years, but the nurses finally got their pensions in 1890. Harriet Tubman got one as well. In the meantime, Wittenmyer used her organizing experience to form the WOMEN'S CHRISTIAN TEMPERANCE UNION in 1874.

## HUNDREDS OF WOMEN HAD SERVED AS NURSES FOR THE UNION ARMY, BUT THEY WEREN'T CONSIDERED WHEN PENSIONS WERE BEING HANDED OUT

It's hard to state how central to society the WCTU became. After spending time in SEWING BEES and other wartime assistance efforts, women were looking to use their sharpened organizing skills to effect more change in the United States. After the massive disruption of the Civil War, the changes brought for and by the newly free African American population, the rapid escalation of industrialization, and the increased influx of immigrants from around the world, progress was unstoppable. To a large segment of the population, particularly White Anglo-Saxon Protestant women who had been relatively happy with the status quo, it seemed the country had fallen a bit off-kilter, and it was up to them to tidy things.

Women weren't normally encouraged to organize themselves into public organizations, but Wittenmyer's WCTU couldn't have been more wholesome. It was widely understood that the women were only doing this because they had to for the good of the country and to protect their godly homes. That is where Wittenmyer planned to leave it.

When **FRANCES WILLARD** became the organization's president in 1879, five years after its founding, that changed. Willard was a feminist.

The work of the WCTU took its members into neighborhoods where proper WASP-y women of means rarely went. Expecting that merely encouraging virtue in the impoverished would enable them to turn their lives around, they instead often learned that a lack of what they thought of as virtue was a result of the poverty, not the cause.

The WCTU members had been particularly concerned with the growing numbers of women working as prostitutes in the country, and because these prostitutes often were immigrants, they were suspected of having brought low morals with them from wherever they came.

The WCTU prevailed on the men who represented them in government to pass laws cracking down on prostitution and its trappings. Time and again, however, they found that after the laws were passed, they were rarely enforced and would often disappear from the books when no one was looking.

Their disappointment with the men they believed they could count on was coupled with their new knowledge of what poverty was really like, and they began to see that there was a structure in place that they hadn't seen before, a system run by men that was maintaining this status quo. Prostitutes weren't women of low character tempting men to betray their virtue; they were women forced to do the only work men provided for them.

With no political voice, women were powerless to change a system that was working against them. Once the members of the WCTU realized this, they began focusing on women's suffrage. Frances Willard would lead them in this new quest.

*PROSTITUTES WEREN'T WOMEN OF LOW CHARACTER TEMPTING MEN TO BETRAY THEIR VIRTUE; THEY WERE WOMEN FORCED TO DO THE ONLY WORK MEN PROVIDED FOR THEM*

*THEY FOUND THAT AFTER THE LAWS WERE PASSED, THEY WERE RARELY ENFORCED AND WOULD OFTEN DISAPPEAR FROM THE BOOKS WHEN NO ONE WAS LOOKING*

## WITH NO POLITICAL VOICE, WOMEN WERE POWERLESS TO CHANGE A SYSTEM THAT WAS WORKING AGAINST THEM

As all this upheaval was going on, the country had reached its Centennial, and the daughters and granddaughters of the Minutemen formed groups to commemorate the accomplishments of their ancestors. The **DAUGHTERS OF THE AMERICAN REVOLUTION** became the most prominent, and its strict rules about documented bloodlines made it popular among those who feared the implications of the high number of immigrants. At the same time, a requirement that all the forebears in lines leading back to a Revolutionary soldier ancestor be the offspring of married parents helped enforce the ban on Black members.

White Southern women were eager to sign up. As the men in their lives signed oaths renouncing their Confederate pasts and swearing allegiance to the United States in order to receive their pensions, women saw the importance of publicly demonstrating their own Americanism. The adherence to strict bloodlines was, of course, also appealing.

As time went on, though, and Reconstruction was rolled back, many Southern

women wanted to celebrate their more recent ancestors and rehabilitate their images. The United Daughters of the Confederacy was founded to promote the idea that the Confederacy was a doomed but noble cause and that slavery had been a necessary institution, beloved and missed by the Black people who had been enslaved.

Really.

The group erected statues and plaques memorializing the Confederate dead and spread the narrative of the LOST CAUSE through children's books and recipe collections. Their efforts were extremely successful. Their version of events became the prevailing story White Americans everywhere in the country believed. In some estimations, this was how the South ended up actually winning the Civil War after all.

Up north, in bustling, industrialized cities, women explored the limits of their assigned roles. Sisters *TENNESSEE CLAFLIN* and *VICTORIA WOODHULL* were free spirits who believed in free love, or a woman's freedom to marry, divorce, have sex, and have children on her own terms. The idea that women should choose when to have sex and when not to was their most controversial idea, and Woodhull was quite serious about it, saying,

> To woman, by nature, belongs the right of sexual determination. When the instinct is aroused in her, then and then only should commerce follow. When woman rises from sexual slavery to sexual

freedom, into the ownership and control of her sexual organs, and man is obliged to respect this freedom, then will this instinct become pure and holy; then will woman be raised from the iniquity and morbidness in which she now wallows for existence, and the intensity and glory of her creative functions be increased a hundred-fold.

Aside from following their own sexual desires, the sisters were interested in showing that they could do other things that men did. They opened the first women-run brokerage firm on Wall Street, and their investments did well. Then they were among the first women to found a newspaper.

The most shocking activity, though, was what Victoria Woodhull did in 1872: she ran for president of the United States. She was the candidate for the quickly formed EQUAL RIGHTS PARTY and chose as her running mate Frederick Douglass, though he didn't seem to know about his candidacy. None of it

*"TO WOMAN, BY NATURE, BELONGS THE RIGHT OF SEXUAL DETERMINATION"*

was particularly legal, since she couldn't even vote, but her bid drew important attention to the cause of women's rights.

Not that the women of the temperance movement were thrilled with her run. She was the opposite of the sober, respectable image of women that they were promoting. The choice of Frederick Douglass as running mate was also a problem, as they were trying to court Southern women and had to appear tolerant of strict White supremacist beliefs.

Already, women in the South were marketing suffrage as a way to increase the number of White votes in their states. This was in keeping with the Lost Cause narrative and its insistence that freed Black people needed to be kept out of power.

Frances Willard, head of the WCTU, started to lean into this a little too much. She supported the banning of alcohol primarily, with women's voting rights meant to be an essential step toward that goal. To that end, she promoted a potential danger to White women now that Black men were free and able to access alcohol.

**IDA B. WELLS-BARNETT** was a journalist in Memphis, Tennessee, at a newspaper she founded with her husband. A Black woman, she was interested in documenting the lives of Black people as they found their way as newly freed people and the resistance they faced. After losing a friend to White vigilan-

*WOMEN IN THE SOUTH WERE MARKETING SUFFRAGE AS A WAY TO INCREASE THE NUMBER OF WHITE VOTES IN THEIR STATES*

tes jealous of his success, she began recording everything she could about lynchings. Through careful research and record keeping, she built up evidence proving that the idea that Black men were a sexual threat to White women was a lie. The relationships between Black men and White women that were used as excuses for lynchings were nearly always consensual, and the lynched men were often in reality economic or political threats to the White community. Wells-Barnett published articles about this not only in her own paper but also nationally, and she pushed hard to pass laws making lynching illegal.

She also worked extensively to expand voting rights for women and was in frequent contact with Frances Willard and the WCTU, often working in tandem with that organization. Naturally, Wells-Barnett was furious when Willard pushed the notion that Black men threatened White women. She knew it would get men killed.

Wells-Barnett called out Willard in a nationally published editorial, lambasting her for being so irresponsible. Willard replied in an editorial that Wells-Barnett had made too much of what she thought were relatively innocuous comments and was being too sensitive. Wells-Barnett shot back with another editorial, to which Willard replied. Wells-Barnett, rightly, refused to back down.

Then, at a major suffrage conference in London, they were suddenly in the same

room at the same time. There was shouting. Some reports claimed blows were nearly exchanged before Elizabeth Cady Stanton stepped between them. The London papers published mocking editorials pointing to the incident as evidence that women couldn't handle having the vote because they were too emotional.

This was an unfortunately rare, public debate over the disrespect White women had for the Black women in the suffrage movement. Alliances would continue to occur, but they were generally uneasy ones.

The North had invested heavily in two technologies that helped it win the war: THE TELEGRAPH and THE RAILROAD. The North's extensive telegraph network had enabled Lincoln to communicate live with his generals in the field, something that had never before been possible, allowing for quick pivots in strategy as new information arrived. The president had spent nearly as much time in the War Department's telegraph room as he had in the Executive Mansion.

The North's railroads, built by private companies but often subsidized by the fed-

**ALLIANCES WOULD CONTINUE TO OCCUR, BUT THEY WERE GENERALLY UNEASY ONES**

eral government, had meant rapid movement of troops and supplies in response to these timely reports from the field.

Midway through the war, Lincoln and a couple of railroad tycoons had started planning a new rail line that would run across the country, which as a result of various wars and purchases now stretched all the way to the Pacific. This presented a paradox: workers were needed to build the western leg of the railroad but would have a difficult time getting there from the East Coast because there was no railroad. Lincoln found a solution through a diplomatic agreement with longtime trading partner China. As long as the agreement stood, workers could travel freely between the countries with no restrictions.

There had already been immigration from China during the GOLD RUSH, and this had provoked violent racist backlash from White people living on the West Coast, even though they had only just arrived there themselves. Chinese workers arriving to build the railroads created "economic anxiety" among White people, who began passing laws similar to the Black Codes in Southern states restricting where Chinese and Chinese American people could live, work, walk, and so forth.

White people had decided that the Chinese were too alien to ever assimilate and fulfilled this belief by preventing them from

**CHINESE WORKERS ARRIVING TO BUILD THE RAILROADS CREATED "ECONOMIC ANXIETY" AMONG WHITE PEOPLE**

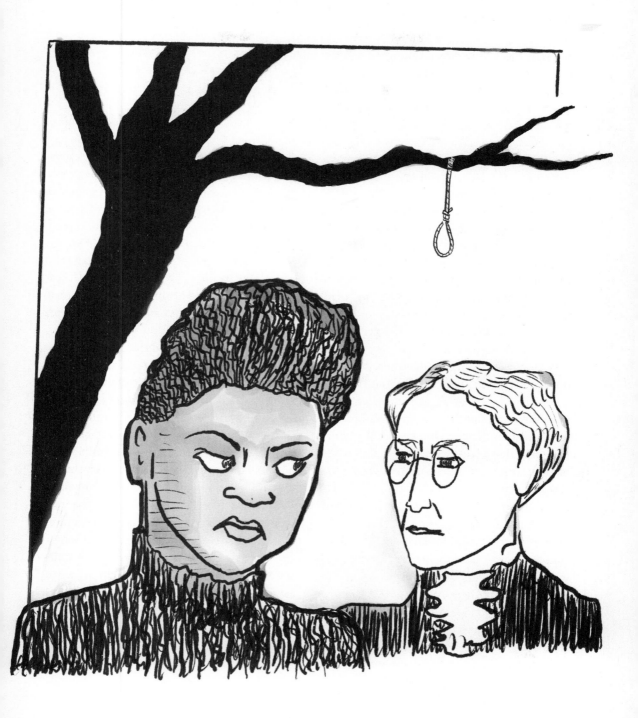

assimilating. People were hung; neighborhoods were burned. Eventually, the White citizens of the West prevailed on the federal government, and the CHINESE EXCLUSION ACT was passed, barring almost all immigration from China despite Lincoln's diplomatic agreement. Chinese women, in particular, were restricted. Because the law specified that no woman could emigrate from China if she was a prostitute, all Chinese women trying to enter the country were then presumed to be prostitutes. Although Chinese and Chinese American women were already in the country, their numbers were far smaller than the number of Chinese men. The new law made the male-to-female ratio even more stark.

Back East, technological changes beyond the railroad were afoot.

Secretaries traditionally were men, but during the Civil War women were brought in to the US Treasury to replace the men who were off fighting. It worked out well enough that after the war, the whole federal government began hiring women for secretarial positions, with preference given to war widows.

By 1890, telephones, typewriters, key-operated calculators, and dictation machines were all making their way into offices. Women were said to be better as typists because their fingers were narrower, but they were also attractive to employers because they could be paid less—more likely the reason they were given these jobs, which were considered drudge work. The men in charge also realized they liked having young women

## THE NEW LAW MADE THE MALE-TO-FEMALE RATIO EVEN MORE STARK

around the office and they liked the power they could exert over them.

As the turn of the century approached, schools sprang up to teach men and women the basics of using all the new equipment. Employers could then hire pretrained secretaries right out of school who could hit the ground running. Attending one of these schools became the primary way for men and women to enter the profession, and training facilities opened all over the country.

Katharine Gibbs came from a prosperous family, and she'd married well, as one would say. Then her husband, who had not yet made a will, was killed when the mast of his yacht fell on his head. Soon after, her brothers stole all the inheritance from her late parents, leaving her and her sister in a precarious financial state. Her sister went to work teaching at a huge commercial secretarial college in Providence.

When Gibbs visited, she was impressed by what her sister was learning but also thought she could do better. After getting some training herself, she set about to make a professional school for women that would train them to be the very best secretaries. A certificate from the Katharine Gibbs school would be a seal of approval that all employers would recognize.

Her dream became a reality that would persist for decades. Employers could hire a **"KATIE GIBBS GIRL"** with confidence.

Gibbs, though, had had a second goal in mind. By training women to be as good as men had been, if not better, she hoped to prove that women were capable of more, that they could go on to be executives, as the men had. She was wrong, unfortunately, to think that the only thing women needed to do to be successful was prove they had the same skills men had and could perform the work as well. Secretarial work became women's work, which demoted its importance in the eyes of the men in charge. Women were put in the position of helpmeet, and stayed there, clearly able to see all the rungs on the ladder rising above them but never allowed to climb.

One thing that kept women from ascending was the assumption that they were just biding their time in a job until they could marry and have children. This was, indeed, generally what women were expected to do, and often what they planned to do. But most women needed to make money, even those who were married, and this was nearly impossible if a woman was pregnant. Certainly, a Katie Gibbs girl who hoped to have even the limited career available couldn't get pregnant. For women further down on the economic ladder, the situation was often already more desperate. Women of all economic situ-

> MOST WOMEN NEEDED TO MAKE MONEY, EVEN THOSE WHO WERE MARRIED

ations had reasons to want to prevent pregnancy until the time was right.

**BIRTH CONTROL** wasn't new. Women . . . and men . . . had been trying to prevent pregnancy since they first discovered sex caused it. Before then, even. Still, in societies like the United States at the turn of the twentieth century, it could only be whispered about in private. Using birth control, helping people acquire it or use it, publishing information about it, sending that information through the mail—all of it was illegal to varying degrees in all of the states and nationally under the **COMSTOCK ACT.**

Not that easy and effective contraceptive methods even existed. With no ability to publish on the subject, no funding, and the constant risk of crossing the law, birth control was not something medical researchers pursued.

The first objection was religious: if God wanted you pregnant, you should get pregnant. Throughout the Old Testament, God constantly makes women barren or blesses

*WOMEN OF ALL ECONOMIC SITUATIONS HAD REASONS TO WANT TO PREVENT PREGNANCY UNTIL THE TIME WAS RIGHT*

them with eight thousand children, or something in between. The message was very clear: your offspring were always a blessing, and you had best be grateful that you were allowed to have them.

Also, there was the matter of the Forbidden Fruit. In the Bible, Eve ate from the Tree of Life and encouraged Adam to join her. In retribution, God had cursed all women everywhere forever and ever with pain in childbirth. This linked the whole experience of pregnancy to women's fates. Women were still paying off Eve's debt.

Women, however, didn't just suffer in childbirth; they also frequently died. **QUEEN ELIZABETH OF ENGLAND** didn't decide to be the Virgin Queen out of prudishness but out of the rational terror that she might get pregnant and die. **QUEEN VICTORIA,** still on the English throne as the twentieth century began, was similarly terrified and surreptitiously tried rudimentary birth control techniques when she was first married. They didn't work, and she spent her first pregnancy in mortal terror—even with the finest medical treatment the world had to offer and all possible material comforts at her disposal.

Imagine, then, the fears of women with none of those resources.

**MARGARET SANGER'S** mother went through nineteen pregnancies, eight of them miscarriages, before she died in her forties. Margaret watched her mother's health deteriorate with every pregnancy and was enraged that her father continued to have sex with her, with no thought to the destruction he was causing. He drank and talked politics at the local tavern while Margaret helped her mother with her siblings, trying to keep them fed on the wages he occasionally brought home.

When she was old enough, Margaret left for college, determined to set herself up with a career so she would never end up as economically dependent on a man as her mother was. She chose nursing, a natural fit after all those years of taking care of her siblings.

She met and married **WILLIAM SANGER,** with whom she eventually had three children. Soon after they married, they moved to Greenwich Village, in New York City, and became deeply involved with the people and radical social change movements based there.

Her nursing skills were desperately needed in the urban slums, and she went right to work. She now saw the potential destructiveness of unwanted pregnancy on a large scale. Aside from the worst possible outcome—death—other common potential long-term health effects were made more likely or worse in the grim environment of tenement life before there was a sanitation department.

At a time when even the wealthiest women didn't have the legal right to refuse sex with their husbands, poor women had even less recourse. On top of that, women who already had children were terrified of having another mouth to feed with a new pregnancy.

Desperate and gruesome self-induced abortions were all too common. Seeing what women were willing to do to themselves in

their distress, even when they knew agonizing injuries and death most likely would result, made Sanger determined to help women prevent pregnancy in the first place.

This is not to say that many poor women weren't delighted to have children. Many were thrilled and raised them in happy and stable homes despite their poverty, as has always been true. Sanger just wanted every woman to have the option to have children only when it would delight her. Sanger wanted every child to be a wanted child. In other words, she supported **PLANNED PARENTHOOD,** which became the name of the organization she founded.

She opened up a storefront where she distributed information and the few available birth control options available. She would get arrested, and then go back to it. She looked for financial and political support where she could, including from eugenists, who wanted to control pregnancies to control the makeup of the population. These were not necessarily her beliefs—aside from wanting babies to be born into healthy situations—but the concepts were mainstream and eugenists had money and clout. Her willingness to ally with them has clouded her name since.

*SEEING WHAT WOMEN WERE WILLING TO DO TO THEMSELVES IN THEIR DISTRESS . . . MADE SANGER DETERMINED TO HELP WOMEN PREVENT PREGNANCY IN THE FIRST PLACE*

Still, what she built lived on. Her efforts, and then the efforts of the organization she founded—along with the many others that sprang up in its wake—have helped millions of women achieve a measure of economic and emotional security through the ability to decide when they were ready to be mothers.

Sanger was, of course, considered too radical by the women in the temperance-related suffrage movement. Though many of them were concerned with the sexual exploitation of women by men and the pregnancies that resulted, they generally preferred to address it by attempting to control male behavior.

In 1913, a combination of suffragist groups staged an enormous parade in Washington, DC. They wore white and donned sashes in the colors of the American women's suffrage movement: purple and gold. *INEZ MILHOLLAND,* a young suffragist who would go on to greatly influence the women's movement, wore a dramatic helmet and flowing robes and rode a white horse at the front, looking amazing. Men jeered and spat at the marchers, but the women continued to look dignified.

So eager were they to reflect what was considered proper, unfortunately, they made Black suffragists march in a group at the back, a shameful blemish on what should have been a day more about real equality.

Younger American women began to find this propriety-focused approach too stuffy. One of these women was *ALICE PAUL.* She tried to work within the WCTU structures but was frustrated with teas and meetings

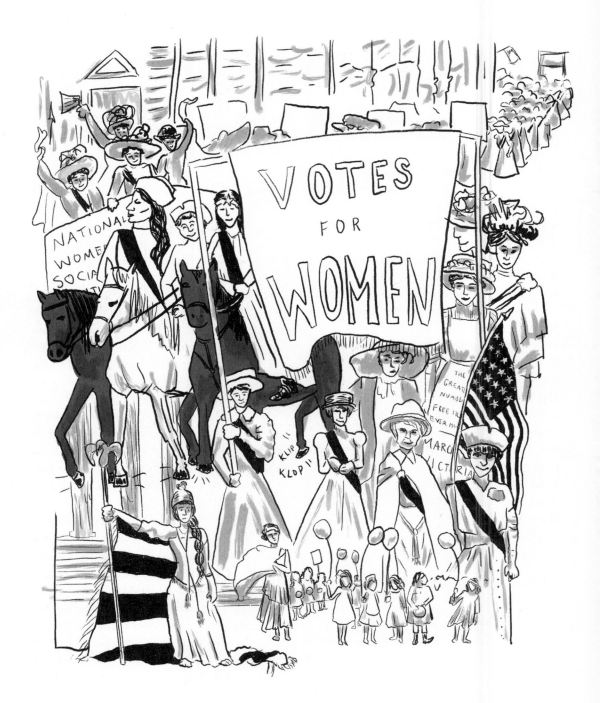

that convinced women but never seemed to push men into action on the issue; with men holding all the political power, they were the ones who needed to act.

She read about **EMMELINE AND CHRISTABEL PANKHURST,** a mother and daughter team who had been smashing London windows and getting arrested, and who encouraged other women to do the same in a push to expand British suffrage to women. They called their cohort the **SUFFRAGETTES,** and they had been generating a lot of attention and gaining a lot of support. Longing to do the same in the United States, Paul traveled to London to study at the feet of the Pankhursts, who were thrilled to teach her what they knew.

When Paul returned, she put her knowledge into action. Organizing other women into the **NATIONAL WOMEN'S PARTY,** she began staging twenty-four-hour protests in front of the White House, holding signs addressed to the president, one of which read, "Mr. President, How Long Must Women Wait for Liberty?"

There had never been this kind of sustained demonstration in front of the White House, let alone by women, and it drew a lot of attention. At first, President Wilson was pleasant about it, waving or tipping his hat as he came and went. He was considered a Progressive, despite extremely racist policies. At the White House, he screened *Birth of a Nation,* a romanti-

> **"COURAGE IN WOMEN IS OFTEN MISTAKEN FOR INSANITY," AS PAUL PUT IT**

> **WITH MEN HOLDING ALL THE POLITICAL POWER, THEY WERE THE ONES WHO NEEDED TO ACT**

cized telling of the founding of the Ku Klux Klan that leaned heavily on the idea that it kept White women safe. He pronounced it "history written with lightning," helping it to become the most popular film in the country and sparking a resurgence of the KKK. He also removed all Black civil servants from the federal government, replacing them with White people, reversing progress made since the Civil War. As to the White women standing outside his gates, he was not necessarily opposed to their suffrage, but he didn't see the issue as urgent. After all, it was just a handful of kooky women.

"Courage in women is often mistaken for insanity," as Paul put it.

Then his attitude changed. Europe had descended into war, and when the United States entered the fray to support its allies, the president expected the full attention of the nation to be turned to the war effort. Alice Paul and her suffragists continued their protests nonetheless. The reception turned hostile.

Eventually, the president lost patience and ordered them arrested. The police officers,

MR. PRESIDENT
YOU SAY "LIBERTY IS THE
FUNDAMENTAL DEMAND
OF THE HUMAN SPIRIT"

also impatient with these unpatriotic and up-pity women, were not gentle, throwing them to the ground as they dragged them off.

When the women began a hunger strike in jail, they were force-fed, with tubes jammed down their throats.

All of this was reported in the papers.

The backlash to the president's actions was severe. The vast network of pro-suffrage women that had grown over all these decades of teas and committee meetings rose up en-raged. This was no way to treat women advo-cating for such a respectable cause.

The president, afraid of losing the support of women whose work he would need in the war effort, changed course and began push-ing to get the amendment extending voting rights to women through Congress. The men of Congress, also afraid of losing the sup-port of all of these organized women, passed

it quickly and sent it to the president for his signature. He signed it right quick and sent it off to the states, where it racked up ratifications and rejections one at a time.

When the **NINETEENTH AMENDMENT** made its way to Tennessee, it was one ratification short. Young, recently elected Harry Burns was supposed to vote against it—he had promised the party bosses he would. Then the night before the vote he received a letter from his mother. She had friends in the WCTU and told him in no uncertain terms he was to vote in support of the Nineteenth Amendment.

So, he did!

He then hid in the attic of the State House for the night to avoid the mobs outside who wanted him dead.

With his vote, enough states had ratified the amendment, and states could no longer ban citizens from voting because of their sex. They still found other reasons to keep certain citizens from voting, of course, and that continued for several decades. Nonetheless, it was a victory for a lot of women, and what followed was a heady time.

## CHAPTER 3

# LET'S MISBEHAVE

## 1920–1939

**FINALLY, THE SEX-BASED RESTRICTION ON VOTING** had been lifted, creating an entirely new voting bloc that required wooing. In anticipation of this, the federal government had also passed the Eighteenth Amendment barring the sale of alcohol across the country in a nod to the temperance movement, which had for so long been connected to the battle for women's suffrage. Some may have thought this would usher in a sober and conservative time in the United States. They were wrong.

Taverns and liquor stores closed, but drinking continued, and it went underground. Women had been restricted from the traditional, more public drinking spaces. No laws or traditions governed **SPEAKEASIES**, the cool, secret clubs that served booze and a bit of a thrill. The White women that so many had fought to keep barricaded away from Black men were now drinking in Harlem, dancing to what mainstream White culture called Jungle Music.

This underground culture coupled with rapidly changing technologies. The 1920 election results were the first to be announced on the radio. Though for decades the telegraph had made instant transmission of information possible, it was still done through a series of one-to-one relationships: the originator gave the message to a telegraph operator, that operator transmitted to another operator, and that operator then transcribed it onto a piece of paper, which could be read by anyone who could read but which required someone to read it aloud or reprint it for multiple people to know the contents rapidly.

**BROADCASTING** was a whole new, amazing thing. The word comes from the field of agriculture and means to scatter seeds widely and rapidly instead of planting them one by one in rows. On the radio, any noise that went into the microphone came out of any radio tuned to that station anywhere within reach of the signal. Instantly, anyone within earshot heard the same transmission: speeches, poems, music, ideas. Cultural seeds

were thrown into the wind and no one knew where they would land.

Movies and records spread cultural experiences, but they were captured dreams. Live radio meant people could experience an event as it happened, either in the company of a group of people or sitting alone at home. Suddenly, the public sphere was everywhere, even in your parlor.

LET'S DO IT,
LET'S MISBEHAVE

Not that the movies weren't the cat's pajamas. The advent of the **TALKIES** meant musical spectaculars. Busby Berkeley was doing hyper, coked-up movies before Joel Schumacher was a gleam in anyone's eye. These movies had dozens of bare-legged showgirls running and dancing and kicking while the cameras shot them from every possible angle. There was no pretense, either. The movies were blatantly about sex. So much sex. Giddy, happy, playful sex.

The songs on record players and the radio kept up the same theme: **LET'S DO IT, LET'S MISBEHAVE**. The dances that went with them were hyperkinetic and athletic, and young women wore short dresses with long fringes and dangling necklaces that made them look like a blur when they moved. As the squeaky, pouty, and White ***HELEN KANE*** sang it in 1929,

*♪ If it's naughty to rouge your lips*
*Shake your shoulders and shake your hips*
*Let a lady confess, I want to be bad! ♪*

The first human-powered flight had happened at **KITTY HAWK** just a few years before, and flying became an activity of the daring. Flight was a new technology, so there were fewer organizations and institutions to tell women no. Women with means took to the skies.

**AVIATRIXES**, as they were called, were all the rage, with ***AMELIA EARHART*** the most famous and daring. She lived to fly and went about setting records, proving that female pilots were no novelty. To finance her flights, she partnered with companies to develop products bearing her name. She promoted an adventurous lifestyle to women through sturdy but dashing luggage and clothes they could move in.

*FLIGHT WAS A NEW
TECHNOLOGY, SO THERE WERE
FEWER ORGANIZATIONS AND
INSTITUTIONS TO TELL
WOMEN NO*

For ***BESSIE COLEMAN***, the first Black female pilot, it had been love at first sight with her and planes. No one in the United States was willing to teach her to fly, so the sharecroppers' daughter saved up money to sail to France and enroll in flight school there. In 1921, she became the first African American woman to earn a pilot's license. On her return to the States, she began performing stunts in shows all over the country, stunning

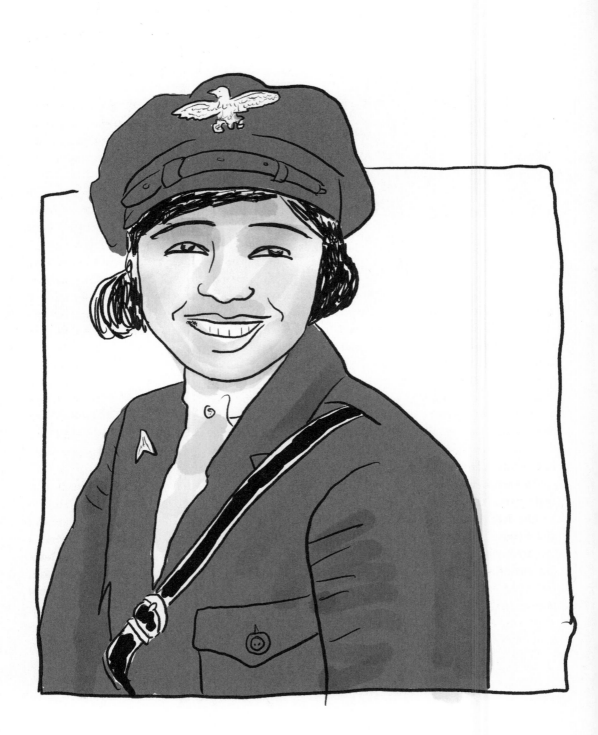

audiences with her skill and courage. She dreamed of starting a string of flight schools, but her life was tragically cut short when one of her planes malfunctioned.

Earhart and Coleman and the other aviatrixes were women little girls—and some grown-up women, too—dreamed of becoming. They made anything seem possible.

# THEY MADE ANYTHING SEEM POSSIBLE

With this crackling sense of possibility in the air, **ALICE PAUL** decided to seize the moment and propose an amendment that would guarantee full, equal citizenship regardless of sex. She drafted a bill and read the text of the **EQUAL RIGHTS AMENDMENT** aloud for the first time in Seneca Falls, at the celebration of the seventy-fifth anniversary of the 1848 women's rights convention held there. At the time, she called it the **LUCRETIA MOTT AMENDMENT,** in honor of the organizer of that historic conference.

The ERA was introduced in the House and Senate, but made no headway. Without the national organizational support and media attention that the Nineteenth Amendment had had, it generated little real interest in Congress. Alice Paul and the **NATIONAL WOMEN'S PARTY** nonetheless continued to introduce it at every legislative session.

These radical changes in society, particularly in the behavior of young women, alarmed a lot of people who had been comfortable with the way things were, thank you very much. As is typical in times of rapid technological and social change, frightened people looked for somebody to blame. As is also typical, these frightened people blamed immigrants and Black people, the old standby scapegoats in American culture.

The **KU KLUX KLAN** rose again, still with the robes, still with the terrorizing of Black people, but also with added anti-immigrant fervor. Also new, Klan members were no longer concentrated in the South—though were still active there, of course, and still killed and raped Black people who tried to vote or run a successful business or walk around comfortably in public. KKK groups sprang up in the Midwest and the Northeast and the Northwest. They made sure that the Nineteenth Amendment applied only to White women. They burned crosses on the lawns of mixed-religion newlyweds in Iowa. They enforced "sundown laws" in small towns in Maine, ensuring that any Black person seen in town after dark would be arrested or worse.

Most frightening was how popular it was. The KKK grew to have the largest membership of any civic group in the country and demonstrated its clout with an enormous march on Washington in 1925. Thirty thousand people tramped down Pennsylvania Avenue wearing their white robes and carrying American flags. Robe-less White people stood along the route and cheered.

Klan membership did decline after that, but mostly because people realized they didn't need to pay membership dues and wear white robes to achieve their aims,

and were often more effective when they didn't. Klan groups evolved into Citizens Councils, civic groups with the same segregationist aims but wearing suits and ties.

The **UNITED DAUGHTERS OF THE CONFEDERACY** continued its push to make the false **LOST CAUSE** narrative the mainstream narrative of the Civil War, ensuring that schoolchildren for decades would be taught that the Civil War wasn't fought over slavery but over "state rights," and that slavery had been ultimately benign, and the best thing

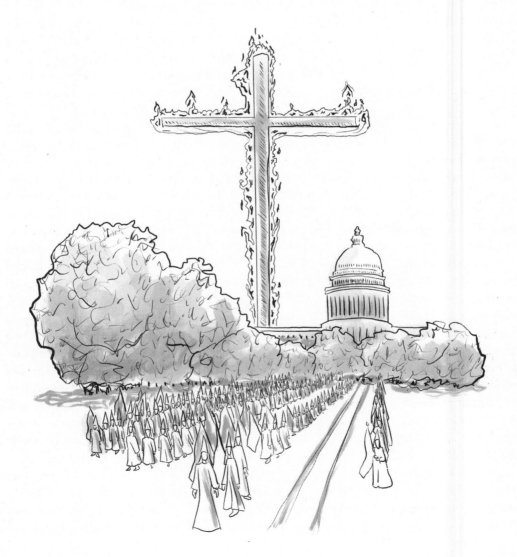

for Black people. The popularity of *Birth of a Nation* had helped, but members knew that getting the story to children at an early age was the key to their success, and through committee work and correspondence, they made sure that every textbook in the United States told the story their way. This would impact how the story of the Civil War was told for decades, which in turn impacted policymaking, judicial rulings, and nearly all other aspects of the public and private lives of Black citizens.

They also began putting up statues everywhere to commemorate various Confederates, at first, well-known historical figures; then later, as the civil rights movement gained strength and began dismantling Jim Crow, the cheaper, hollow generic soldier statues that we've seen recently crumpling as they're pulled from their pedestals across the country. What would have been maybe their most horrific statue, though, was thankfully never built at all.

The Jefferson Davis Chapter of the UDC, located in North Carolina, concerned that people still weren't understanding that Black people had actually been incredibly happy as slaves, thought it would be just super if the Mall in Washington, DC, had a statue "in memory of the faithful slave mammies of the South."

No. Seriously.

The "mammy" had become a beloved stock figure in American popular culture, showing up in minstrel shows and on sheet music, in cookbooks and on boxes of pancake mix. She was an entirely fictional character, a jolly, heavy-set, dark-skinned woman with a kerchief wrapped around her head. She was occasionally sassy, but generally happy with her lot. She cooked, cleaned, and raised White children without complaint.

In reality, it had been enslaved girls who usually tended to their owners' children, and like all enslaved people, they were beaten if they weren't subservient.

The statue would not be of one of these girls, it would be of the minstrel show version, a big, smiling woman holding a White baby at her breast. She would be perched atop a plinth, and carved from stone. With the help of their representative, the Jefferson Davis Chapter of the UDC's plan was presented to the Senate, which approved it. Land was granted, and designs were submitted.

None of these White people understood how much time Black Americans had spent organizing themselves since the war. The **NATIONAL ASSOCIATION FOR THE ADVANCEMENT OF COLORED PEOPLE** (NAACP), the **NEGRO WOMEN'S CLUBS,** and other powerful organizations had built themselves into powerhouses, and Black newspapers across the country had large and devoted reader bases. Protest was heard from all corners. The Mammy statue was scrapped. She was still on that pancake box, and would pop up in film time and again, but she wasn't memorialized in stone in the nation's capital.

> THIS WOULD IMPACT HOW THE STORY OF THE CIVIL WAR WAS TOLD FOR DECADES

Still, Washington, DC, remained a largely segregated town, not through laws on the books but by staunchly defended tradition. Residents of the city would continue to challenge that tradition, some more successfully than others.

In one of those confusing quirks of history, **ELEANOR ROOSEVELT** was Eleanor Roosevelt even before she married. Her husband was her fifth cousin once removed, and they shared a last name. She was, though, of the more prominent Roosevelts, Teddy's favorite niece, while her husband's branch was merely rich. They had always enjoyed each other's company, though she was shy and bookish and he was a bit of a playboy, and they seemed like a good match. This was especially true for Franklin, who wanted a career in politics and could only benefit from closer association with her uncle.

Franklin was a sheltered rich boy, though, and rightly considered a bit of a lightweight by some of his colleagues. After putting in some time on Wall Street, he made headway in politics through his determination and connections, but his lack of understanding of the lives of regular people made him a hard sell to everyday folks.

Eleanor did not feel that she took to mothering naturally, but she fell into the role enthusiastically. She'd had a lonely, traumatic childhood, so a bustling home was of some joy to her. A shy person, she enjoyed less the duties involved in marriage to a public figure but was pleased to support her husband, whom she loved and considered a partner.

Then she discovered correspondence between him and her personal secretary, **LUCY MERCER,** that clearly showed they were having an affair. Eleanor was devastated. She could no longer trust a close friend and confidante or her life partner. She confronted him, he admitted to the affair, and she offered to give him a divorce. But his mother, **SARA DELANO ROOSEVELT,** forbade it, saying she'd cut him off without a cent if he divorced Eleanor. Sara didn't particularly like Eleanor, but she foresaw big things for her son, and a scandal like a divorce would get in the way.

Eleanor agreed to stay in the marriage on the condition her husband cut off contact with Lucy Mercer. She would also no longer share a bed with him.

Lucky enough to have money and a staff to watch her children, Eleanor reinvented her life. She traveled more and forged friendships with great artists, thinkers, and revolutionaries. Some of these friendships even turned into romances. She became politically active, helping organizations that worked for civil rights and labor rights and women's rights. She still loved her husband, and considered him a friend and partner, but they lived separate lives.

Suddenly, in a time before vaccinations, Franklin was struck with polio. His illness and recovery meant reworking their marital arrangement, but not entirely. She tended to him when she was home, but she continued her work and travel. They had money, they had staff, she was free to do that.

Her husband was bedridden for a long time, unable to move in any active way. He

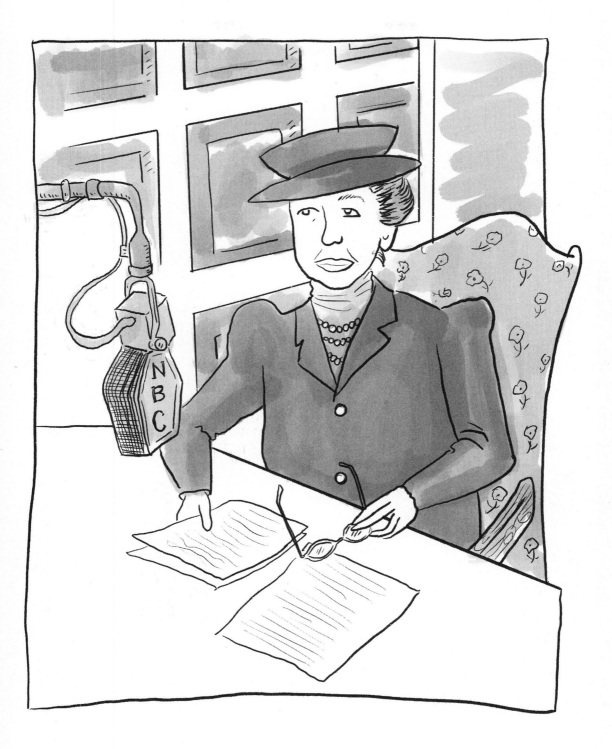

was angry, depressed, frustrated. His dreams seemed unattainable. Then, after spending all that time alone thinking, he found some strength inside himself to hold on to. He had began to get a little better. He wanted to get a lot better. He had money. He had staff. He went out into the world. He found something that helped. He found a community. He changed.

A person can take one of two approaches after experiencing suffering. One is to want others to suffer like you did. The other is to connect with others who are suffering and to help each other. Eleanor's husband chose the second option.

They then became a proper team, a couple who pulled together and then released. It was that teamwork that won them the White House.

The giddiness of the twenties had ended abruptly in 1929 when the falsely inflated **STOCK MARKET** crashed, destroying precarious fortunes in an instant. The entire country plunged into the worst depression it had ever experienced. Those who suffered the most weren't the people who had inflated the stock market in the first place, but the people who worked for their companies, who cleaned their homes, who did their bookkeeping.

The current occupant of the White House was ill suited to the task at hand, so in the next election the voters chose Eleanor's husband to sit in the Oval Office. With his background in finance and his active compassion, not to mention his charm and optimism, he seemed like the right person for the job.

Eleanor took on the role of **FIRST LADY** with great enthusiasm, transforming it to fit the life she was already leading. She traveled, she made speeches, she connected with people and listened to what they had to say, always wanting to learn more about what she could do to help. She insisted that her press conferences be attended only by female reporters, forcing newspapers across the country to hire some. She did what she could.

Her husband appointed as his secretary of labor **FRANCES PERKINS,** the first woman to ever hold a cabinet position. In this role, she oversaw most of the key aspects of the president's **NEW DEAL**, a comprehensive plan to alleviate financial hardship and get people back to work. Infrastructure projects were launched, arts-based initiatives were begun, educational and archival projects were formed all to create jobs for the hungry. Today we still benefit from the creations that came out of those initiatives. Perkins also set up social security programs, unemployment benefits, and welfare payments for those who had no other options.

Unfortunately, much of it was implemented to benefit primarily White people. Most of the New Deal programs were strictly segregated—they couldn't pass through Congress in any other way because too many White people were uncomfortable with the idea of Black people having any sort of equal standing or benefits. This didn't mean that

some New Deal opportunities didn't open up to Black people, and those that did helped the Black middle class expand its ranks.

In 1935, **MARY McLEOD BETHUNE** founded the **NATIONAL COUNCIL OF NEGRO WOMEN,** an umbrella group for twenty-eight preexisting Black women's groups working on civil rights issues.

Sixty years old at the time, Bethune had spent decades in a leadership position for one Black women's group or another and had consulted with more than one president, so she was the perfect person to take on this coordinating role.

One of Eleanor Roosevelt's closest friends, she also created the **FEDERAL COUNCIL OF NEGRO AFFAIRS**, a coalition of Black leaders from around the country. Serving as an advisory council to the president, it became known as the **BLACK CABINET.**

In this way, through her friends and associates, Roosevelt was able to have a wider influence on her husband's administration without looking like she was stepping too far outside her First Lady role. Not that she wasn't regularly accused of forgetting her place anyway.

In one great public symbolic moment, she got to take a stand against the continued segregation in DC. In 1939, **MARIAN ANDERSON,** the brilliant, world-renowned singer, was scheduled to sing at **CONSTITUTION HALL** in DC, which was owned by the Daughters of

**TODAY WE STILL BENEFIT FROM THE CREATIONS THAT CAME OUT OF THOSE INITIATIVES**

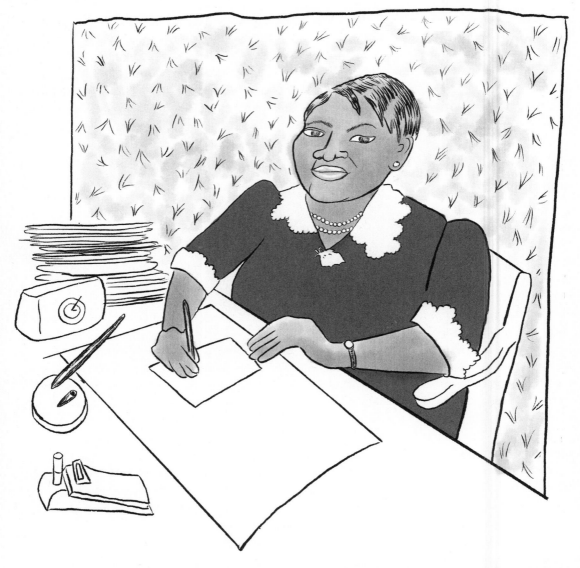

the American Revolution. Whereas they were more than happy to have Anderson, a Black woman, sing on stage, they balked when she said she would sing only in front of an integrated audience, and immediately canceled the concert. The DAR was willing to lose ticket sales and a chance to hear this voice to uphold segregation.

Eleanor, a DAR member, was livid when she heard this news and announced to the

world that she was withdrawing from the organization. Then, with the support of her husband, she gave Anderson the opportunity to stage a concert on the steps of the LINCOLN MEMORIAL. Seventy-five thousand people from all backgrounds and of all colors turned out to listen. The first words Anderson sang were "My country, 'tis of thee, sweet land of liberty, of thee I sing."

This didn't end segregation in Washington, DC, or anywhere else, but it was a beautiful moment. The civil rights movement took those when it could. A long road lay ahead.

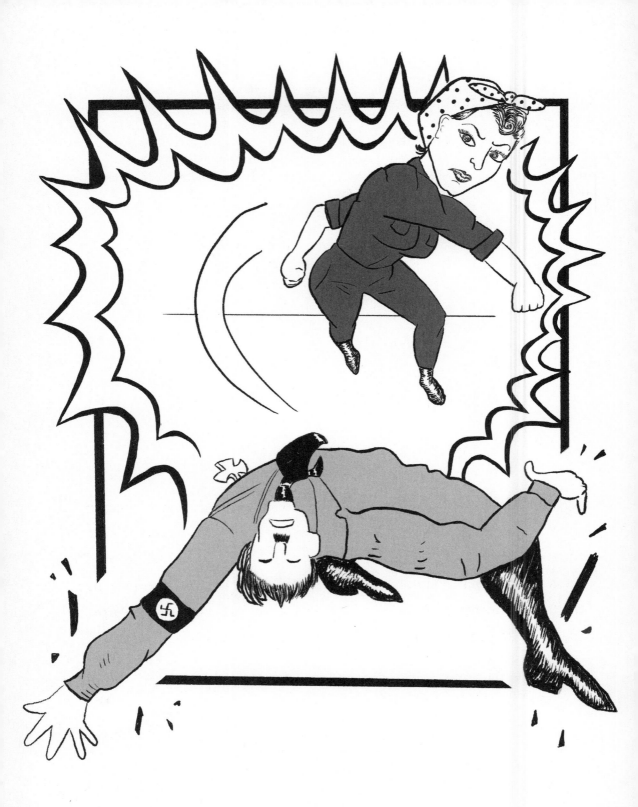

# CHAPTER 4

# WE CAN DO IT!

## 1940–1949

**WE ARE CARRIED ALONG BY HISTORY.** We are born into a specific time and place. How people with bodies like ours are treated at that time and in that place has a profound impact on how our lives progress. If Frederick Douglass had been born in the Abyssinian Empire in the late thirteenth century, his life would have been entirely different. Ida B. Wells-Barnett would have had completely different experiences if she'd been born in Englewood, New Jersey, in 1973.

Our historical location is like the air around us. We're only aware of it when the wind blows.

In early **DECEMBER 1941,** 353 airplanes left Japan, flew halfway across the Pacific, and in less than half an hour radically changed America's future. The hurricane raging on the other side of the world arrived on our shores.

The United States declared war on Japan and its Axis allies, Italy and Germany, after the bombing of **PEARL HARBOR.** American men, and the women who would be nursing them, headed overseas to fight all over again.

Back on the home front, the United States launched the largest coordinated industrial production effort the world had ever seen. Factories that had produced cars and radios and nylons were repurposed to build tanks and bombs and parachutes. With most of the men overseas, women were yet again asked to leave their homes to contribute to a war effort. The domestic sphere expanded to include the entire country.

Overseen by the great **FRANCES PERKINS,** the women working in factories were known as "Rosies" after **ROSIE THE RIVETER.** Portrayed by **NORMAN ROCKWELL** crushing *Mein Kampf* under her foot while eating her lunch and on the iconic **"WE CAN DO IT"** posters, Rosie the Riveter's role was summed up in the catchy tune celebrating her work:

♪ *Rosie's got a boyfriend, Charlie.*
*Charlie, he's a Marine.*
*Rosie is protecting Charlie*
*by working overtime on the*
*riveting machine.* ♪♪♪

Though the Rosies were represented by illustrations of White women, in real life they came from all backgrounds, as did the men at the front. Women of color experienced the same feeling of dissonance as men after being asked to pull together to defend a country that considered them lesser citizens.

> *WOMEN OF COLOR EXPERIENCED THE SAME FEELING OF DISSONANCE AFTER BEING ASKED TO PULL TOGETHER TO DEFEND A COUNTRY THAT CONSIDERED THEM LESSER CITIZENS*

During World War II, the soon-to-be-legendary **PAULI MURRAY** was enrolled in the law school at **HOWARD,** the historic Black university and center of legal efforts to overturn racially discriminatory laws. The only woman in the class of 1944, she was attuned to the anger among the male students over being drafted to fight for a country that seemed to hate them. At the time, Washington, DC, was a segregated city by tradition, if not by law—"Where Jim Crow rides the American eagle," as she described it—so Howard students were reminded of this hatred each time they entered certain establishments.

After one particularly egregious incident in 1943, when three women from Howard were arrested for ordering hot chocolate at a downtown store, students organized a group that would confront this problem head-on.

Murray was one of three women who led a protest at the **LITTLE PALACE CAFETERIA,**

"WE CAN DO IT!"

attracted more attention. But the administration at Howard worried that the university might lose its grant from the federal government, a sizable chunk of income without which it couldn't operate, and asked the students to stop protesting. Understanding the tight spot the school was in, they did stop, but they never forgot the power they had wielded merely through stool-sitting, and they made sure future generations knew about it.

This prepared the Howard students themselves for the future, equipping them with skills for the bigger fights they'd face down the road. An example of what they'd face as civil rights lawyers and activists happened in Abbeville, Alabama, the next year.

That **RECY TAYLOR,** a Black woman, was raped by White men was not all that unusual. It was a fairly regular occurrence in the Jim Crow South, part of the general efforts to keep Black people in line. What made Recy Taylor's case different was that she was willing to speak out about it. That was a dangerous thing to do, so exceedingly rare, especially when it was a certainty that a Black person could not get actual justice from the American justice system. She wanted to bring charges anyway.

The NAACP office in Montgomery heard about the case and sent the branch's secretary, **ROSA PARKS,** to Abbeville to interview

a restaurant near Howard known for serving only White people. They went in and asked to be served. As expected, they were refused, but they sat down anyway and started reading books of poetry they'd brought along. Soon, a few more Howard students showed up and asked for service, then sat down when they were refused. After forty-five minutes, the restaurant was filled with Howard students, and the manager shut the place down.

The students continued to protest outside with picket signs. After two days, the Little Palace Cafeteria relented, changed its policy, and began serving Black people.

When the students next took the protests downtown to a cafeteria that was part of a national chain, they were briefly successful and

*THIS PREPARED THE HOWARD STUDENTS THEMSELVES FOR THE FUTURE, EQUIPPING THEM WITH SKILLS FOR THE BIGGER FIGHTS THEY'D FACE DOWN THE ROAD*

Taylor. Made secretary of the branch because she was the only woman there, Parks was eager for a chance to fight injustice in the field. She had known her share of rape stories that were whispered but never spoken of aloud. This was an opportunity to fight back.

As Parks sat in Taylor's home taking down the details of the story, the town sheriff drove back and forth out front. He finally burst in and threatened to arrest Parks if she didn't leave town, but not before she'd gotten the information she needed.

Back in Montgomery, she typed up Taylor's story: the woman had been grabbed by a group of White men while she was walking home from a church revival. They claimed she'd stabbed a White boy and needed to be punished. They took her into the woods and took turns raping her, threatening to slit her throat if she screamed. When it was over, they took her back to where she'd been grabbed and left her there blindfolded by the side of the road. Her father found her later staggering along the road in the dark.

Though the men had warned her that they'd find her and kill her if she told anyone, she reported the rape to the sheriff the next day. One man confessed, and named the others involved, but no arrests were made.

With Taylor's blessing, Parks was going to tell this story far and wide in the hope that action would be taken. She launched the **ALABAMA COMMITTEE FOR EQUAL JUSTICE FOR THE RIGHTS OF MRS. RECY TAYLOR,** and she and its members shared the story all over the South, distributing flyers everywhere and gaining the attention of the press. Soon, the story was published in newspapers outside the South, and reporters headed down to Abbeville to interview Taylor and take her picture with her family.

Despite all this, two grand juries refused to indict the men who had raped her. The White men who ran Alabama knew what Rosa Parks knew: this case was the thin edge of a wedge that could crack segregation wide open in the justice system. They could give no leeway.

Parks, though, had learned something about those White men: they were scared, holding the system together by sheer will. Parks, meanwhile, wasn't going anywhere. She'd stick this out as long as was needed.

Meanwhile, other civil rights fights were less visible but just as dramatic.

The shameful **CHINESE EXCLUSION ACT** had prevented immigration from China for the previous fifty years, and discriminatory laws all over the country had relegated those Chinese and Chinese Americans who were already in the country to certain jobs and sections of town. Attempts to break out of these constrictions were met with violence and terror.

Japanese immigration was also limited. Though not in such a dramatically specific way, **JAPANESE AND JAPANESE AMERICANS** faced similar constrictions to Chinese and Chinese Americans.

> **SHE'D STICK THIS OUT AS LONG AS WAS NEEDED**

The similarity between their experiences was about to change dramatically.

When the United States went to war with Japan after the **PEARL HARBOR ATTACK,** the nation immediately became an ally of China, which was fighting its own battle with the Japanese. In a gesture of goodwill, the US government repealed the Chinese Exclusion Act, which had long caused tensions between the countries. The end result wasn't all that dramatic, because Chinese immigration was cut off at just over a hundred people a year, but it was a start, and an important gesture.

Japanese people in the United States and Japanese Americans, however, were cast under a cloud of suspicion. A similar attitude toward German Americans had pervaded during World War I, and they had been required to register with the government. This time around, this was not the case with German Americans because they had managed to do a lot of hasty assimilating in the intervening years since the First World War, but much worse was about to happen to Japanese people and Japanese Americans in the United States.

The anger against Chinese and Japanese immigrants in the West had always revolved around their taking land that White people believed should belong to them, even though all three groups of people had arrived on that land around the same time.

In the years leading up to World War II, Japanese Americans, like so many other Americans, farmed in the West, raising not only culturally Japanese crops but also crops that were popular with the general American population, which put them in competition with White farmers.

Now was the opportunity to kick them off their farms and look patriotic doing it. In 1942, the president signed **EXECUTIVE ORDER 9066** authorizing regional military commanders to remove anyone of Japanese descent from their homes and place them in internment camps. Any possessions they had that didn't fit into a suitcase were confiscated. Over a hundred thousand people, most of them born on American soil, many of whom had male relatives fighting for the United States, lost their houses, land, businesses, and possessions.

After the war, not wanting any more trouble, most of those interned quietly went about rebuilding their lives. *MINÉ OKUBO,* a Japanese American artist who spent the war in an internment camp, did not want to remain silent. In 1946, she published *Citizen 13660*, a collection of the line drawings she'd done of the camps while she was held there. It was the first published work that

addressed what had happened, and it encouraged others to share their experiences, helping to begin the process of deciding what to do about it.

Most women in the United States, aside from those who had volunteered as nurses or other jobs that took them overseas, remained at the home front. As a result, most didn't see the horrors so many of the returning men had seen, creating a greater divide between the public sphere and the domestic sphere. So many men had romanticized their future homes while overwhelmed by the horrors of war and they longed to return to a peaceful nest. This would have a profound influence on the policies and societal structures of the postwar period.

Meanwhile, with the exception of those who were lesbians or bisexual, a large number of, in particular, young women had

physically missed male bodies. The return of the men sparked a massive hormonal reaction and launched the Baby Boom.

The work the Rosies had done during the war had, of course, ultimately been in support of men and their work. It was meant to be an exception to normal life. Though many women were happy for the chance to live a quiet domestic life raising children and running a household, for others it felt limiting.

Even those women who happily became housewives had been awakened to the capabilities of women. Their experiences working in jobs that had been traditionally considered men's work showed them how arbitrary that designation was.

This was, of course, primarily a major realization for middle-class and upper-class White women, because women of color and White working-class women had rarely had the privilege of not working outside the home. Still, jobs that had been designated for men paid more, meaning women were being deprived of money based on gender discrimination alone, not capability.

For instance, the women who programmed ENIAC, one of the earliest electronic computers, didn't receive the pay or respect the men who had built it did, even though they had to develop the programming protocols themselves and had a far greater understanding of the machine's inner workings

than did the men who had welded it together. It was decades before their accomplishments were even acknowledged outside their little circle, even though their work became the basis of so much of what would follow.

Just a year and a half before the attack on Pearl Harbor, the **REPUBLICAN PARTY** added a call for the ratification of the **EQUAL RIGHTS AMENDMENT** to its party platform. The Democratic Party followed in 1944. This was a result of the years of effort made by *ALICE PAUL* and her **NATIONAL WOMEN'S PARTY**. It was also a nice poetic twist that the party of the abolitionists was the first to sign on to this corrective to the Fourteenth Amendment.

So, the decade had started out with one of the major political parties' committing to gender equality, followed by the other in the middle of the decade. To reconcile this with women's forced return to the domestic sphere, an effort was made to apply the **"SEPARATE BUT EQUAL"** concept to the sexes by talking up the value of homemaking.

Talk, however, is cheap, and the economic lives of women reflected that. As the United States entered its new phase as the richest country the planet had ever seen, our female citizens would begin to wonder why their roles in this dynamic society were so constricted.

> *TALK, HOWEVER, IS CHEAP, AND THE ECONOMIC LIVES OF WOMEN REFLECTED THAT*

The country had spent the first half of the forties telling women they were capable of anything and applauding their power. Women's historic achievements were celebrated in books and movies. ROSALIND RUSSELL chose her career over life in the suburbs in *His Girl Friday*. *PEGGY GUGGENHEIM* promoted female artists. WONDER WOMAN comic books, launched during the war, included a "Wonder Women in History" feature.

But at the war's end, many of the returning men were anxious to rein back all this empowerment.

The next decade was going to be interesting.

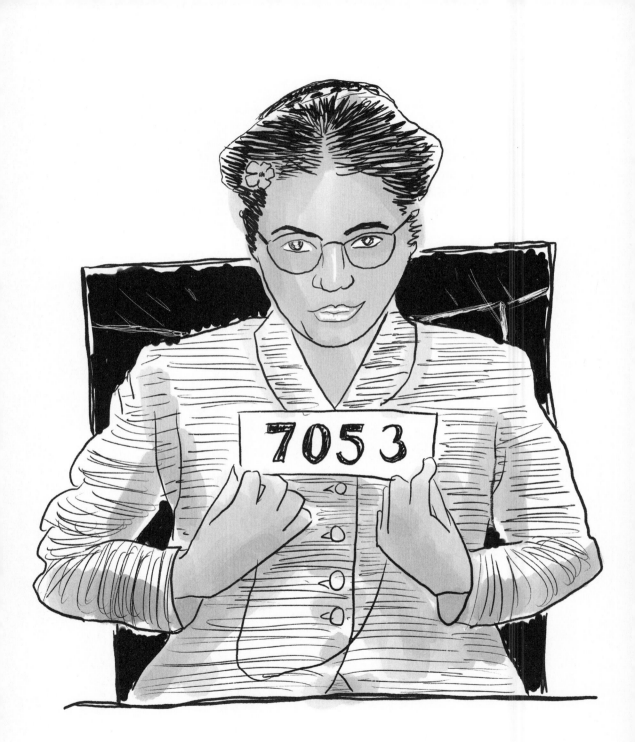

# TOMORROWLAND

## 1950-1959

*THE MEN SETTLED IN AT HOME,* and Europe and Asia rebuilt. All the coordination and patriotism of the war effort poured into the post-war economy, and with no real competitors, the United States became the most prosperous nation that had ever existed in the history of the planet. Taxes were high, and the US government—larger than it had ever been or ever would be again—invested in infrastructure, research, and education for the future. Acres of housing were built for veterans. Some was public housing, but the Federal Housing Administration also guaranteed loans so veterans could buy houses and pay mortgages that were a fraction of what they'd pay to rent an apartment.

The future was everything. People wanted to be modern and streamlined after the grubbiness of the war and the Depression before that.

We also found ourselves in a cold war competition with the SOVIET UNION after both nations became atomic powers. The world seemed to be divided into two philosophies that competed head to head, capitalism versus communism, and the pressure was on. The United States had to model the superiority of capitalism.

As the decade progressed, more and more attention and resources were paid to the atomic threat. Schoolkids were taught to duck under their desks, basements of city halls were marked as fallout shelters, and suburbanites were encouraged to build bomb shelters of their own in their backyards. None of these actions would have actually protected anyone from a nuclear attack, but perhaps people liked having hope.

Black Americans knew that the threat to their safety and quality of life came from far closer to home. JIM CROW LAWS were still in effect across the South, and Black Americans were barred from living in these new suburbs of the North.

The STUDENT SIT-INS in DC and the ALABAMA COMMITTEE FOR EQUAL JUSTICE FOR THE RIGHTS OF MRS. RECY TAYLOR hadn't achieved all of the activists' specific goals, but they had helped move the needle, giving people a glimpse of possibilities.

In 1951, sixteen-year-old *BARBARA ROSE JOHNS,* a Black high school student in Farmville, Virginia, organized a student strike to protest the underfunding of her school and the other Black schools in the segregated state. Her uncle was prominent in the civil rights movement, so she had access to knowledge and institutional strength. Separate but equal was the law of the land, but the equal part was rarely upheld. Johns and her classmates froze in the wintertime in their dilapidated school building and walked to school while the White kids rode past them in buses. When the population of their school got too big for the building, the overflow of kids had to attend classes in hastily built tarpaper shacks.

## SEPARATE BUT EQUAL WAS THE LAW OF THE LAND, BUT THE EQUAL PART WAS RARELY UPHELD

NAACP lawyers came in to assist and agreed to help the students sue the school district, but under one condition. For years, civil rights groups had focused on enforcing the equal part of separate but equal. Now, spurred on partly by legal arguments written by *PAULI MURRAY,* they were looking to dismantle the separate part. They wanted to sue for integration. The action started by Barbara Rose Johns went on to become one of the four cases that led to the *Brown v. Board of Education of Topeka* decision in 1954, which overturned the separate but equal rule and mandated an end to segregation in schools.

In 1955 came probably the best-known act of resistance to segregation when **ROSA PARKS** refused to give up her seat on a bus to a White man. Though at the time she was widely portrayed as merely a tired seamstress who had suddenly had enough, she was, of course, a highly experienced civil rights activist who had been waiting for this moment for a while.

**CLAUDETTE COLVIN,** another Black resident of Montgomery, had done the same some months before, but she was fifteen and falsely rumored to be pregnant by a married man, and civil rights organizers were concerned that she wouldn't be sympathetic to the White people they hoped to bring to their side. Rosa Parks's action wasn't specifically planned, but she'd been ready for an opportunity, and she didn't look like the radical she was.

It's well known that the day after Parks was arrested, the Black community in Montgomery began a boycott of the city buses that lasted for just over a year; they coordinated rides and walked and hung together as the buses drove around the city more than half empty. We certainly know about the reluctant preacher the civil rights activists pulled in as their spokesperson.

What's less well known is that the segregation on buses didn't end because the city of Montgomery suddenly saw the error of its ways and relented. It ended because after the boycott started, noting the positive response it was getting around the country, NAACP lawyers pulled together a federal lawsuit challenging segregation. Colvin was a plaintiff along with **AURELIA BROWDER, SUSIE MCDONALD,** and **MARY LOUISE SMITH,** who had also been discriminated against by Montgomery bus drivers.

In November 1956, the SUPREME COURT upheld the decision of a lower court and ordered Montgomery to desegregate its buses. The city waited to be handed an official notice to end segregation before it would do so. Handed the notice on December 20, they desegregated, and that is when the boycott ended.

The combination of compelling public protest and smart legal action worked and provided a model not only for the civil rights movement but also for other movements to come.

*THE COMBINATION OF COMPELLING PUBLIC PROTEST AND SMART LEGAL ACTION WORKED AND PROVIDED A MODEL . . . FOR OTHER MOVEMENTS TO COME*

It has not gone unremarked in the years since that one of the factors in turning public opinion for the boycotters was that Black maids were unable to get to work on time during the boycott. White women all over the country relied on Black women to help keep their houses up to the standard of tidiness and efficiency that was expected. Black women weren't allowed to live in the new suburbs, but they spent a lot of time cleaning them.

Neat and respectable homes were an important part of the image of prosperity and success the country needed to project to

the world, and there was a lot of pressure on White women to keep up appearances. **HOME ECONOMICS** was a required class for White girls in preparation for the work they would be doing as homemakers. Full of actual useful information on how to cook nutritious meals, how to sew, how to keep a house organized and clean, and other practical knowledge, the classes never included boys—it was assumed their future wives would do these things for them.

At the same time, there was an explosion of teenage girl sexual energy. **ROCK AND ROLL** is often portrayed as a male thing, but it would have gone nowhere without teenage girls. They shaped it, first the Black girls, and

then the rest of them. If the girls didn't like a song, artists didn't have a hit and might as well not play at all.

Obviously, it was terrifying to the White powers that be, who had devoted so much time and energy to prevent "race mixing," that White girls were getting excited by the music and voices of Black men. Government-licensed radio stations didn't play records by Black people or rock and roll by anyone. But White suburban teenagers listened to the radio in their cars, and they could drive to spots where they could pick up one of the illegal radio stations that broadcast rock and roll at night. Or they could head to a drive-in that had a jukebox. Or throw a sock hop

and play forty-fives on their portable record players.

It goes without saying that these suburban teens in the fifties were also having sex in those cars, with their tail fins and enormous backseats. Unfortunately, girls weren't taught about BIRTH CONTROL in home economics classes. There wasn't much birth control available to girls in the 1950s anyway, aside from counting on the boys or men they had sex with to pull out or wear a rubber.

As had been true for decades, the options for pregnant unwed girls and women were limited: get married as soon as possible, be-fore the pregnancy showed; pretend to visit a distant aunt while waiting to give birth, at which point the baby was taken away; or get an illegal and usually dangerous abortion. These things were whispered about at kitchen tables and over back fences, but rarely spoken out loud.

Then came *Peyton Place*, the trashy and fantastic novel by **GRACE METALIOUS** that blew the lid off of respectable small-town America. Set in a quaint village in New Hampshire with a picturesque town square and white clapboard churches, the novel exposed the hypocrisy of respectability. Inside

the tidy houses that lined the quiet streets, incest was going on and homosexuality, inappropriate attractions, and passionate premarital sex.

Most shocking of all, there was abortion, and it was portrayed as the absolute right thing to do in the circumstances.

*Peyton Place* became the most popular book in America, the new thing that women whispered about at kitchen tables and over back fences. So much of it was so familiar, and women had a lot to talk about.

As the fifties drew to a close, the number one movie in America was *Pillow Talk*, starring ROCK HUDSON and **DORIS DAY**. It was the perfect movie to end the decade.

Doris Day plays JAN MORROW, a supertalented and successful interior designer in New York City who is, of course, single and who, of course, lives alone. The major plot device involves some explaining: even by 1959, not everyone had their own phone line. Neighbors often shared a line, which was called a "party line." Each residence on the party line had its own special ring, and you were only supposed to pick up calls that came in with your ring. You also weren't supposed to listen in on your neighbors' calls—there was a whole etiquette to party lines—but you could, if you were careful, and this led to all sorts of hijinks.

You also couldn't make a phone call or receive one while your neighbor was on the line. The lovely and talented Jan Morrow shares a party line with a song composer and cad named Brad, played by the ridiculously handsome Rock Hudson. Brad is FOREVER yapping with women on the phone, flirting and tapping out songs for them on his piano. This means Jan basically can never use the phone or receive a call, and she gets madder and madder at him.

Then Brad stumbles across Jan, discovers she's a hotty, and launches an effort to woo her. Knowing she'd hate him if she knew his true identity, he pretends to be Rex Stetson, a rich and gentlemanly Texan. He's the ultimate white patriarch, the perfect cover for Brad . . . and, as it turned out, for Rock Hudson himself. But we'll get to that later.

Jan finds out he's lying at a key moment, of course, so she stabs him to death and does hard time upstate. KIDDING! After initial anger, she actually falls in love with him for real, marries him, and gives up her career. The Fifties were a trip!

The movie is all clean lines and pastel candy colors. Nearly all of the banter is playfully suggestive, and split screen is used throughout to place the characters physically next to each other even when they are not, with the opening sequence winking at the thin illusion of the line between them. The chemistry between the characters is HOT.

In the midst of all these sexual hijinks, the postwar era lurched into the sixties.

## CHAPTER 6

# YOU DON'T OWN ME

## 1960–1964

**THE SIXTIES WERE ALL SET** to be the fifties but with the cleaner lines and subtler color palette. Thanks to the GI Bill and large-scale government investment in schooling at all levels, the US population was more educated than it had ever been. Thousands, if not millions, of White men used their GI Bill degrees to get steady office jobs, and the mortgages the Federal Housing Administration guaranteed them as veterans enabled them to buy prefab homes in suburban housing developments with lawns they could mow. White women married these men and stayed home to keep the modern kitchens tidy and get their kids off in the morning to the newly built schools.

In 1960, the country elected the youngest man to ever hold the office of president of the United States. He was handsome and stylish and so modern that he often didn't wear a hat. His wife, **JACKIE,** was glamorous and clever but soft-spoken and unobtrusive. They had two adorable kids who knew how to behave but still had a bit of moxie. They were a Catholic family, but these were modern and tolerant times, and enough people looked past it to vote for him. The house they moved into was a bit larger than a prefab suburban, and there was a bit more lawn to mow, but it was all still familiar.

The same year, the *Dick Van Dyke Show,* a smart television show about a husband and wife who looked an awful lot like the couple who had just moved into the White House, debuted. **LAURA PETRIE,** the wife on the show, even had Jackie's hair.

One of the finest sitcoms ever created, with sharp writing and a ridiculously talented cast, the *Dick Van Dyke Show* also showcased perhaps the most appealing portrayal of the domestic/public split ever to be seen. Laura took her roles as wife, mother, and homemaker seriously and found joy in the work they required. When she was going through a rough patch, her best friend lived next door to assist as necessary. Her husband's job writing for a television variety show was prestigious and fun, and the liveliness of the office often came home with him; their amazing parties and dinners often turned into variety shows staged right in their living room.

The Petries also very clearly had the hots for each other in a way that was rarely shown in married couples on TV. Married TV couples were polite with each other, or cranky with each other, or exasperated with each other. The Petrie marriage was a deeper portrayal of real love.

These were people who respected and supported each other, and when they weren't hosting Catskills revues in their home, they did address their occasional frustrations with their gender roles. When Laura used judo to flip a drunken man who'd punched her husband, her husband felt his masculinity called into question, and he openly admitted that though he didn't want to beat up his wife, he wanted to know that he could. When Laura returned to her premarriage career to sub as a dancer on her husband's show for a week, she had an amazing time but turned down a regular slot because dancing made it too hard to get her housework done. None of the women who worked on the show were married, and even **SALLY,** the brilliant comedy writer, said she'd give up work if she could ever find a husband.

These same issues were playing out in the **WHITE HOUSE,** but that was real life, so less attractive and less funny. The sharp and witty

*THESE SAME ISSUES WERE PLAYING OUT IN THE WHITE HOUSE, BUT THAT WAS REAL LIFE, SO LESS ATTRACTIVE AND LESS FUNNY*

but shy Jackie had given up professional dreams and opportunities to be marriageable, and from the outside it looked like she had won the marriage lottery. In actuality, she was stuck with an occasionally abusive if charming womanizer. As First Lady, she was obligated to perform as the country's pretty, put-together, and welcoming hostess. She was elevated above, but similar in many ways to the bunny-costumed hostesses at **PLAYBOY CLUBS** whose unglamorous real lives would soon be exposed by scrappy young undercover reporter *GLORIA STEINEM.*

*ELEANOR ROOSEVELT,* who had experience with the First Lady role and the expectations placed on women, was furious, if not necessarily surprised, when Jackie's husband appointed no women to high-level positions, rolling back progress—albeit relatively minor and token-based progress—on women's rights that had begun when her husband had appointed the first woman to a cabinet position. Each president since had appointed more women to important positions in government until Kennedy's term.

Roosevelt, along with other women also infuriated by this step backward, pressured Kennedy to do more for women. At the suggestion of one of the few women in his administration, *ESTHER PETERSON,* head of the **WOMEN'S BUREAU IN THE DEPARTMENT OF LABOR,** he eventually established the **COMMISSION ON THE STATUS OF WOMEN**

*EACH PRESIDENT SINCE HAD APPOINTED MORE WOMEN TO IMPORTANT POSITIONS IN GOVERNMENT UNTIL KENNEDY'S TERM*

and appointed Eleanor as its leader in the hopes of getting into her good graces.

The commission's charge was to find whether progress had been made on equality for women, but it inherited the battle over what equality meant. This was rooted in the debate over the role women should play in the public sphere given the reality that so many women already worked outside the domestic sphere. That Peterson's bureau was part of the Labor Department pointed to her long career working to help women who were already serving as the breadwinners in their households. Her success in that career had been helped by her careful habit of publicly noting that OF COURSE women's work should ideally be limited to the roles of wife, mother, and homemaker if only we lived in an ideal world.

This meant she was regularly at odds with *ALICE PAUL* and the **NATIONAL WOMEN'S PARTY,** who continued to push for passage of the **EQUAL RIGHTS AMENDMENT.** Peterson, like many others who had worked within the labor movement, was concerned that passage of the ERA would destroy protections for women in the labor force that had been gained through tremendous struggle. She had instead made small gains in equality through laws and policies that had been finessed so as not to affect existing protections. In the meantime, she made sure the ERA was tied up in various committees.

Roosevelt had been Peterson's mentor, and had similar concerns about the ERA, so Peterson felt confident in her appointment to head up the commission. The commission, consisting of prominent policy-minded women and a smattering of men, thus began its work in 1961 with the unstated hope that it would prove the ERA unnecessary.

The commission included several Black women, such as the formidable **DOROTHY HEIGHT,** chair of the **NATIONAL COUNCIL OF NEGRO WOMEN** since 1957. The primary focus for most politically active Black women, however, was the civil rights movement. There was so much work to be done, and Black women were doing so much of it.

**ELLA BAKER,** widely considered the greatest political organizer of all time, had been doing social justice work since she'd attended college in the 1920s. She had held major positions in the **NATIONAL ASSOCIATION FOR THE ADVANCEMENT OF COLORED PEOPLE** and the **SOUTHERN CHRISTIAN LEADERSHIP CONFERENCE.** The **GREENSBORO SIT-INS** in 1960 inspired her to use her unparalleled organizing experience and skills to help student leaders across the country build themselves into a truly national movement.

She pulled together a meeting of student leaders out of which the **STUDENT NONVIOLENT COORDINATING COMMITTEE** was born. With this solid base, combined with the thrilling energy of the young leaders, SNCC attracted students into the movement who might not have felt as comfortable joining smaller or less stable groups. White kids,

"MY THEORY IS, STRONG PEOPLE DON'T NEED STRONG LEADERS"

who had rarely been interested in participating in more minor civil rights actions, joined SNCC to be part of something that felt big and solid and exciting. Their presence helped SNCC gain mainstream attention and sympathy that all-Black protests never got.

This was the kind of result Ella Baker perpetually sought: a broad movement that depended on strong organization, not strong leaders. As she put it,

> You didn't see me on television, you didn't see news stories about me. The kind of role that I tried to play was to pick up pieces or put together pieces out of which I hoped organization might come. My theory is, strong people don't need strong leaders.

She became increasingly uncomfortable with the public elevation of one man as the de facto leader of the civil rights movement, knowing as she did the danger of making people think their freedom depended on the accomplishments of a single person. As someone who had often fought for women's

rights, she knew how disingenuous it was for such a broad movement to be attributed to the efforts of a single man.

Unfortunately for Baker, human beings like a clear narrative, with well-defined heroes and villains. When history is being told, too many tangents and a multitude of characters make the storyline hard to follow. It is even more complicated to follow along as events are unfolding, so journalists who write history as it happens choose to focus on a few compelling individuals they think will draw readers and viewers into a story, and they tuck the more mundane facts in around these characters.

It's true, too, that charismatic and confident leaders can stir things within us and burrow into our memories in an outsize fashion. Those who were at the 1963 MARCH FOR JOBS AND FREEDOM in Washington, DC, would later tell of seeing the REVEREND MARTIN LUTHER KING JR. speak in a way they didn't speak of others who took to the stage that day. They certainly regarded him with more awe than they did the people who had worked hard to set up the sound system that allowed them to hear his words.

Indeed, King's speech that day has long been considered one of the finest speeches given by any human being, and the first thing children are taught about the man is that he had a dream. Though only CBS showed the march live, as news of the massive attendance and the rousing speech spread, the other networks quickly put together reports with highlight reels so that soon most of

America had heard King make reference to America's founding documents:

> When the architects of our republic wrote the magnificent words of the Constitution and the Declaration of Independence, they were signing a promissory note to which every American was to fall heir. This note was a promise that all men, yes, black men as well as white men, would be guaranteed the unalienable rights of life, liberty, and the pursuit of happiness. It is obvious today that America has defaulted on this promissory note insofar as her citizens of color are concerned.

## *"IT IS OBVIOUS TODAY THAT AMERICA HAS DEFAULTED ON THIS PROMISSORY NOTE INSOFAR AS HER CITIZENS OF COLOR ARE CONCERNED"*

As King noted, Black men had been fighting to be considered equal to White men for decades. In a society in which manhood was defined, in part, by dominion over women, there was pressure never to let Black men look like they were overshadowed by the women in their lives. Black women often found that they were expected to put the goals of the larger civil rights movement above their own need to be recognized as fully and equally human.

What wasn't shown on TV, either live or later, was the final-straw moment for female leaders of the movement. Only one woman was on the planning committee for the march, **ANNA ARNOLD HEDGEMAN,** a prominent civic administrator. She was furious to discover that the men on the committee had not scheduled a single woman to speak, just to sing. After she complained, and quietly called on other prominent women to complain, the men compromised and added a short presentation titled **"TRIBUTE TO NEGRO WOMEN FIGHTERS FOR FREEDOM"** to the program for the day.

Five women would sit on the stage: **DOROTHY HEIGHT,** the chair of the National Council of Negro Women; **DIANE NASH BEVEL,** tireless organizer of the **FREEDOM RIDERS; DAISY BATES,** fearless newspaper publisher who chronicled and assisted the efforts of the **LITTLE ROCK NINE; PRINCE LEE,** widow of the sharecropper activist shot to death for transporting voting rights activists two years earlier who now was raising their eight children on her own; and the legendary **ROSA PARKS.** They were to be introduced by **MYRLIE EVERS,** whose husband, **MEDGAR EVERS,** had been shot to death in their driveway, in front of their children, in retaliation for his leadership in the civil rights movement.

On the day of the event, Evers got stuck in traffic, so **A. PHILIP RANDOLPH,** organizer of the **BROTHERHOOD OF SLEEPING CAR PORTERS** and respected elder of the movement, took it upon himself to introduce the women on stage, despite seeming not to know some of their names. The women stood and smiled but were not given an opportunity to speak.

After the march, the prominent male leaders headed to the White House to speak with the president, a meeting that finally pushed Kennedy to introduce a civil rights bill. None of the women were invited along, not even Dorothy Height, who had stood next to King as he gave his speech.

The next day, Height called a meeting of the National Council of Negro Women to discuss what had happened. She had kept quiet publicly about the goings-on in the lead-up to the march, not wanting to air dirty laundry, but she had had enough.

**BETTY FRIEDAN'S** *The Feminine Mystique* had been released a few months before the march. A deeply researched and sharply written cri de coeur from a brilliant woman who felt trapped in the married homemaker role she'd been taught to desire, the book might seem unrelated to the concerns of Black women who had been part of a fight that sought, in part, to give them the opportunity to live the kind of middle-class life that would allow them to be married homemakers.

In **"YOU DON'T OWN ME,"** recorded the same year *The Feminine Mystique* came out, **LESLEY GORE** defies a controlling boyfriend, demanding he stop telling her what to do or say, telling him to stop seeing her as a toy. As the song builds in intensity, she sings out,

*I'm young, and I love to be young!*
*I'm free, and I love to be free!*

White women were battering the bars of their gilded cages.

Black women, of course, had actually BEEN owned a century before. Now many of them worked as maids in these White homemakers' households, so they knew best how phony this "feminine mystique" myth was that Friedan described. Many felt the need to resist being forced into a similar trap, even while they wished for the option.

The August NCNW meeting had gone so well that another was called for November. **PAULI MURRAY** gave a talk in which she urged her colleagues to action: "The Negro woman can no longer postpone or subordinate the fight against discrimination because of sex to the civil rights struggle but must carry on both fights simultaneously." Copies of the talk circulated among Black women for years after as a stirring feminist call to arms.

The report from the President's Commission on the Status of Women had been released just a few weeks before, and the findings were not exactly what Esther Peterson had hoped. She had chaired the commission for its final few months after the sudden death of Eleanor Roosevelt, so she was able to downplay the results in the report, but everyone involved, including Dorothy Height, knew that they'd come to the unavoidable conclusion that the Equal Rights Amendment was absolutely necessary if women were to gain any real parity with men. Still, it was the report that softened that finding that was sent to the president. State commissions were set up to further study the issue.

Then there was the **ASSASSINATION**—the shocking, sudden, awful assassination that turned everything on its axis.

There was Jackie, as we've seen her a million times in the Zapruder film, smiling and waving, then cradling her husband's bleeding head in her arms, and then crawling onto the back of the car screaming. Later, stoic and brave in the suit still covered in his blood, showing the world what had been done, watching the vice president be sworn in as president. Later still, draped in black, letting go of her son's tiny hand as he stepped forward to salute his father's passing coffin.

Out of a sense of respect, the new president retained the same cabinet and pushed to follow through on promises the slain president had made. One of these was the civil rights bill that had been discussed in August.

The new president was a tough negotiator and from south of the Mason-Dixon line—two characteristics that gave him an edge over Kennedy in the matter. With the help and guidance of the civil rights leaders who'd met earlier with Kennedy, **JOHNSON** managed to get a bill with real teeth written and passed. It didn't contain the voting

> "THE NEGRO WOMAN CAN NO LONGER POSTPONE OR SUBORDINATE THE FIGHT AGAINST DISCRIMINATION BECAUSE OF SEX TO THE CIVIL RIGHTS STRUGGLE BUT MUST CARRY ON BOTH FIGHTS SIMULTANEOUSLY."

rights language the civil rights leaders had wanted—that would come in the next bill—but it required real concrete actions to be taken in a way previous civil rights bills had not.

It was strong enough that it splintered the **DEMOCRATIC PARTY**, the party of **ANDREW JACKSON**, which had been home to the Southern segregationists for decades. The new president told these **DIXIECRATS** in a blistering speech behind closed doors that their time of reckoning had come, that they wouldn't be coddled by the party anymore. It was time to join the modern era. Instead, they eventually packed their bags and left the party. The **REPUBLICAN PARTY**, which had been the abolitionist party a hundred years earlier, took them in, a choice that would change future politics in dramatic ways.

Those segregationists had represented the Southern states for so long because those states kept a tight rein on who they allowed to vote. A Black person even attempting to register to vote could be killed. This had persisted long enough that most Black people had stopped trying. It was as if the Fourteenth and Nineteenth Amendments didn't exist in certain states.

The SNCC began chipping away at this injustice immediately after its founding, recruiting students to travel to these states to educate the Black population on their rights and organize them to register and vote. They were met with extreme violence, and many of the students and allies they'd brought on board were brutally beaten and often killed.

**FANNIE LOU HAMER** grew up in Mississippi in a sharecropper family and became a sharecropper herself. It wasn't until she attended one of the SNCC's educational meetings in 1962 that she learned she had the right to vote. She was forty-four years old.

> "NOW I'M SICK AND TIRED OF BEING SICK AND TIRED."

She attempted to register to vote at the first opportunity, in August of that year, taking a bus with others to Indianola. The next day, she was kicked off the plantation she'd worked for eighteen years, and her husband was fired from his job. With nothing left to lose, she decided to work as a field organizer for the SNCC, traveling around Mississippi teaching people about the rights she'd only just learned she had.

The next year, on the way back from an organizing session, her bus was pulled over and she was arrested along with two others on board. At the jailhouse, she was beaten so badly she suffered permanent kidney damage, developed a blood clot in her eye, and was left with a limp for the rest of her life.

The beating only made her more determined to fight, and she began telling her story at SNCC meetings around the country. "All my life I've been sick and tired," she said in an interview. "Now I'm sick and tired of being sick and tired."

Smart, tough, and compelling, with a knack for connecting with people, she was

"I QUESTION AMERICA"

soon asked to run for office, mostly to show that it could be done. She became a candidate for the **MISSISSIPPI FREEDOM DEMOCRATIC PARTY,** an alternative to the state's segregationist branch of the Democratic Party. The real aim was to unseat the official state delegation at the 1964 convention, or at least be seated alongside them in the hall, with the argument that the official delegation was illegitimate because they hadn't been elected by the full voting population of the state.

To drive home the point, the MFDP asked Hamer to tell her story to the convention's credentials committee. Knowing what an engaging speaker she was, the networks were there prepared to broadcast her speech live. A few minutes in, President Johnson, still trying to hold on to those Dixiecrat votes some-

how, panicked and declared an impromptu news conference to preempt her airtime.

That just meant the networks broadcast her remarks later, during prime time, so the nation got to hear the details of what was done to her when she had simply tried to vote. The nation also heard her ask,

> I question America. Is this America, the land of the free and the home of the brave, where we have to sleep with our telephones off of the hooks because our lives be threatened daily, because we want to live as decent human beings, in America?

In the second half of the decade, America would have a chance to answer.

The country was also in for a bit of a surprise.

In the lead-up to the passage of the **CIVIL RIGHTS ACT,** in a last-ditch attempt to stop it, opponents backed the addition of a provision they were sure would tank the act. Originally introduced by socially progressive members of Congress, the provision would add gender discrimination as an offense to be prosecuted in employment situations. The labor unions had, of course, been fighting the Equal Rights Amendment for years because of fears of how protections and job classifications might be upended. The opponents of the civil rights bill assumed that labor would never let this provision get through.

They were wrong. The Civil Rights Act passed with the gender discrimination language intact.

This went unnoticed by most, but not by the women who had already begun organizing. For the first time in the country's history, a national law had been passed banning employment discrimination based on gender. A whole lot of women were waiting to see what would happen next.

## CHAPTER 7

# WOMEN IN REVOLT

## 1965–1970

**OPPONENTS OF THE CIVIL RIGHTS ACT OF 1964** cynically supported inclusion of gender in Title VII, the section forbidding discrimination in employment, in the hopes their colleagues might consider it a bridge too far and scrap the whole thing. It didn't work, and for the first time ever there was a law broadly forbidding discrimination in the workplace based on gender. Coupled with the Equal Pay Act of 1963, employment equality seemed to be at hand.

Unfortunately, once formed, the **EQUAL EMPLOYMENT OPPORTUNITY COMMISSION** continued to treat gender as an afterthought. Five members of the commission would vote on which cases the commission would pursue, and time after time the two members who wanted to address gender-based cases, **AILEEN HERNANDEZ** and RICHARD GRAHAM, were outvoted by the three members who wanted to ignore all gender-based discrimination cases in the hopes that they would just go away.

They did not go away. The aftershocks of the Presidential Commission on the Status of Women continued to reverberate.

**PAULI MURRAY** had been working in civil rights law since graduating from HOWARD LAW in 1944. She had gone to Howard because HARVARD LAW, after initially accepting her into the program, rejected her upon finding out she was a woman. Since then, she'd experienced much of the same disregard and sidelining that other women experienced working in the civil rights movement, as she had so famously discussed at the second NATIONAL COUNCIL OF NEGRO WOMEN gathering.

Murray was an early advocate for changing the focus of civil rights law away from making things equal to ending the separation of races instead, and she was beginning to see that similar issues were at play for women. The attempt to keep men and women in separate spheres while giving lip service to their equal value had failed women, and a new approach was needed.

In partnership with **MARY O. EASTWOOD**, a lawyer in the Office of Legal Counsel at the **DEPARTMENT OF JUSTICE**, Murray expanded the speech she'd made at the NCNW meeting into the now legendary paper published in the *George Washington Law Review* in December 1965: **"JANE CROW AND THE LAW: SEX DISCRIMINATION AND TITLE VII."**

The paper called for recognizing that sex discrimination was as serious as race discrimination and should be addressed with similar fervor. It also lamented that the EEOC had failed to do this.

Like her NCNW speech, the paper was widely circulated, and this time among White women as well. Murray had named "the problem with no name" that **BETTY FRIEDAN** had lamented in *The Feminine Mystique*.

Friedan had also become frustrated with the inaction of the EEOC and with the refusal of the leadership of the Presidential Commission on the Status of Women to even make statements of complaint. Murray's paper was a brilliant legal argument that formalized what she'd been saying.

*MURRAY HAD NAMED "THE PROBLEM WITH NO NAME"*

Friedan contacted Murray. Pause for a moment, reader, to appreciate the historic moment. This was a stone thrown into a pond that is still causing ripples today.

Friedan urged Murray to put together an organization, start a real movement. But Murray had her academic life to focus on and legal cases to pursue. Beyond that, she was a lesbian at a time when being one was risky if discovered. She was also realistic about who would be taken seriously in the world and knew that a White woman would achieve a greater audience than a Black woman would. She told Friedan that she would back her up, but that Friedan should lead the charge. Friedan was already in the public eye and more than happy to make a scene.

They put together a bit of a plan.

In 1966, both attended the **THIRD NATIONAL CONFERENCE OF COMMISSIONS ON THE STATUS OF WOMEN,** Murray as a delegate and Friedan as an observer. An attempt was made to bring a resolution to the floor denouncing the EEOC's inaction and announcing a call to action. The federal organizers, concerned about ruffling feathers, refused.

At that point, Murray, Friedan, and twenty-six others, including ***SHIRLEY CHISHOLM*** and ***ANNA ARNOLD HEDGEMAN,*** marched to Friedan's hotel room, already stocked with snacks and booze, to form an organization to pursue gender discrimination cases. Friedan scribbled the name of the new organization on a paper napkin:

The acronym conveyed their sense of urgency. The full name, the **NATIONAL ORGANIZATION FOR WOMEN,** described its mission.

To bring attention to a situation that would also draw attention to their overall cause, they decided to focus on the many complaints brought to the EEOC by flight attendants, then known as **STEWARDESSES.** Stewardesses held a magical place in the public imagination. Adventurous girls dreamed of entering the only profession widely available to women that allowed them to travel. Stewardesses were seen as glamorous, sophisticated, and fun.

Girls weren't the only ones who dreamed of stewardesses. Airlines carefully crafted an image portraying stewardesses as doting, attractive, and available. Airplanes would be a domestic sphere in the clouds, a place of retreat for men weary from their lives in the public sphere.

The popular paperback *Coffee, Tea, or Me?* capitalized and expanded on that image, particularly the "available" part. Sold as sassy memoirs written by two freewheeling stewardesses always looking for a bit of fun with a handsome fella, they were, predictably, secretly written by a man.

Airlines had strict rules intended to maintain this tantalizing image. Stewardesses had to meet guidelines on age, weight, and grooming. Then there was the issue of availability. So that businessmen would not have to worry they were eyeing—or patting—the bottom of another man's wife as she pushed the drinks cart down the aisle, airlines required that stewardesses be single. Getting hitched got you fired.

## GETTING HITCHED GOT YOU FIRED

In reality, stewardesses were highly trained professionals. They knew about cabin safety and flight routes and how best to cope with air sickness and fear of flying. They had to keep a level head in an emergency and guide passengers through whatever crisis might occur. Treating them like eye candy was demeaning. They wanted respect and they wanted proper compensation. Their de-

mands, with the support of NOW, met with some success, though it was slow going, as change always is. But the attention around their actions inspired others to pursue gender discrimination complaints.

**HERNANDEZ** and **GRAHAM** ultimately left the EEOC to work with NOW—Hernandez eventually became its president—and their deep knowledge of the EEOC's procedures and policies helped fine-tune the complaints that NOW backed.

The **ECONOMY** was beginning to shift away from the postwar bubble, when families could afford a car and a house with a yard on one White man's salary, and this shift contributed as much to women's entering the workforce as did the problem with no name. Much of the legal work at the beginning of second-wave feminism focused on equal pay and equal employment opportunity.

That was the quiet background work that was going on. Nothing else was terribly quiet in the late sixties.

As mentioned, when the men came home from the war in 1945, most of them wanted to immediately marry a woman, settle down, and have some babies. Most women wanted that, too. More to the point, men and women had been separated from each other for a lot of years, and there was a lot of pent-up sexual desire among straight people. The end result was lots and lots of babies, and the oldest of those babies hit early adulthood in the mid sixties.

These had been the teenagers **PRESIDENT KENNEDY** was addressing in his famous statement about not asking what their country could do for them, but what they could do for

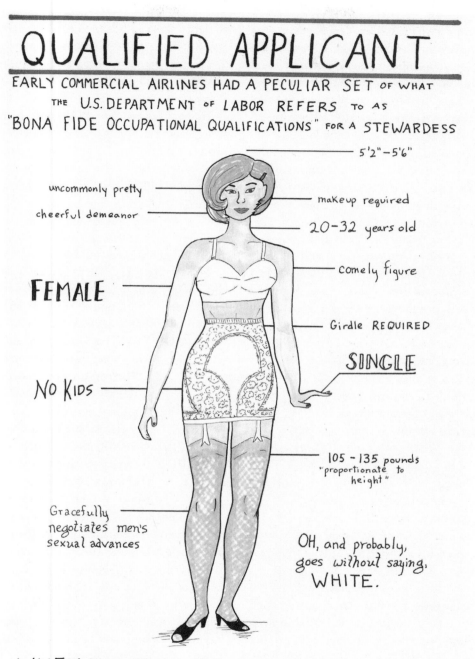

their country. The **PEACE CORPS** was created specifically for them. Though his assassination devastated most Americans, perhaps it hit the baby boom generation the hardest, popping the bubble of suburban comfort that the postwar economy lent to the childhoods of so many, at least of the White kids.

Kennedy also left behind a small military action that was growing into a pretty big war, and with the draft still active, more and more young men were shipped off to be ground up in the gears of the Domino Theory. Their parents had told them tales of **WORLD WAR II**, the way the country pulled together and made noble sacrifices to fight a great evil. As the years passed, and more and more young men were killed for less and less clear reasons, many young people began to question this war's purpose. They were sacrificing, but for what? They began to rise up against it.

Many had been involved in the civil rights movement, registering voters with the **SNCC**, engaging in civil disobedience, marching, and those who hadn't participated had heard about it from those who had. The organizing seeds **ELLA BAKER** had planted were starting to sprout and spread their own seeds.

The antiwar movement took hold on college campuses around the country. There were marches, sit-ins, draft card burnings. Buildings were occupied. Some joked that students were protesting more than studying. Students, though, had the opportunity to protest, because young men enrolled in college couldn't be drafted. Everyone knew young men who weren't so fortunate.

Young women, though they were not at risk of being drafted, took part in the organizing and protests, too. In time, they discovered what the women in the civil rights movement had discovered before them: they might be marching side by side with men, getting beaten and arrested along with the men, but they were still expected to make dinner when everyone got home.

Meanwhile, the fight for civil rights had shifted its focus.

Although the nonviolent protests of the **SOUTHERN CHRISTIAN LEADERSHIP CONFERENCE** and the behind-the-scenes legal fights had ended **JIM CROW** in the South—and in a massive victory that affected the whole country, interracial marriage was legalized with the *Loving v. Virginia* decision—things had changed little in the North, where racism was less openly encoded. It was harder to battle widespread police brutality than segregation on a single bus line.

Since the **GREAT MIGRATION**, when thousands of Black people left the South for opportunities in northern cities, there had been a pronounced division between Black urban culture and Black Southern culture, and

> **THEY WERE SACRIFICING, BUT FOR WHAT? THEY BEGAN TO RISE UP AGAINST IT.**

BLACK
IS
BEAUTIFUL

just let the curls come back; they let the curls grow into glorious brown halos around their heads. **ANGELA DAVIS,** a leading member of the **BLACK PANTHER PARTY,** which was fighting police brutality in Oakland, California, with dramatic shows of force, popularized the hairstyle, soon dubbed an afro. She looked like a gorgeous, powerful queen with her fist as her scepter and her afro as her crown—and who wouldn't want to look like that?

The assassination of **MARTIN LUTHER KING JR.** forced younger Black Americans to further question how useful attempts at respectability were if this man, who held himself under such careful control, could be killed anyway.

*Black is Beautiful* became the popular catchphrase associated with the movement toward accepting and loving Black bodies as Black bodies.

White women, of course, were subject to their own harsh beauty standards, and many of them also stopped overstyling their hair and let it grow out in its own directions.

Men, too, grew out their hair as gender roles were reevaluated and the hypermasculinity that led to the never-ending war overseas was increasingly questioned.

even Southern cities could seem "country" to Northerners. Young people in the North, in particular, weren't always interested in dressing in their Sunday best and singing hymns while they marched. They wanted to be a little louder with their Blackness.

For Black women, this came to mean not processing their hair to make it look straight. For generations, Black women, and men, who wanted to look "respectable" had been treating their hair with harsh chemicals to make it look more like the hair of White people. There had always been arguments about it in the Black community, and a sadness that there was such a negative view of Black physical features, but in a world so dominated by White people, it didn't feel like there were many options.

The advent of the **BLACK POWER** movement, which advocated being unapologetically Black and unapologetically forceful, made the younger generation feel more comfortable letting their hair be free. They didn't

*THE HYPERMASCULINITY THAT LED TO THE NEVER-ENDING WAR OVERSEAS WAS INCREASINGLY QUESTIONED*

The reawakened women's movement matched the radical intensity of the other political and social movements. The **NEW YORK RADICAL WOMEN FEMINISTS COLLECTIVE** was one group that formed to push the issues women were facing into the national consciousness.

Just south of New York City, down the coast, was Atlantic City, home of the **MISS AMERICA PAGEANT.** What had started in the twenties as an attempt to embrace and promote the young, athletic, bob-haired modern women of the era had become a symbol of female objectification and control. The NYRWFC decided it was time to have some fun and spread some knowledge. In 1969, they paid a visit to the pageant.

Outside, on the boardwalk, they carried protest signs, handed out pamphlets, and crowned a sheep as a humorous and pointed illustration of how similar the judging of Miss Americas was to the judging of farm animals at a fair. They lit a fire in a trashcan they'd brought and dubbed it the **FREEDOM TRASHCAN.** Into the can they dramatically threw symbols of stifling femininity, including mops, Playmate attire, high heels, girdles, and—in what would prove to be their defining moment—bras.

Inside the hall, as the former Miss America made her farewell speech, four members who had purchased tickets to the event unfurled an enormous banner from the balcony that read WOMEN'S LIBERATION. They then shouted the phrase as they were escorted from the hall. Though the TV cam-

eras never showed them, the reporters in the audience noticed them, and soon the phrase was in every newspaper and talked about on TV news in reports on the bra-burning feminists who'd crashed the pageant.

The same year, a radical feminist artist officially broke up the **BEATLES** by marrying one of them. Well, not exactly, but that was the story that stuck. Though **YOKO ONO,** an influential avant-garde artist who had emigrated from Japan to the United States in the late forties, was well established in the downtown New York art scene, she was viewed by the general public as a crazy exotic woman who had destroyed something they loved. The Beatle himself had started out as an artist and was delighted to be a bit freer with his life. Together, they played with his celebrity, using it and subverting it with protests and albums and writing and art. Theirs came to be viewed as one of the great models for a marriage of equals.

The structure of marriage, with the husband having dominion over the wife, was intensely questioned in the feminist movement, and some of the strongest questioning came from lesbian members, who didn't fit into this framework at all. Many were attracted to the women's movement precisely because their outsider status made them see the absurdity of gender roles more clearly.

At the same time, feminists were often accused of being lesbians, a label they fought. One reason **GLORIA STEINEM** was such an effective evangelist for the cause was that she looked like a conventionally attractive White woman, she wore cool clothes, and she dated men. Young women who were afraid to embrace

> THE STRUCTURE OF MARRIAGE WAS BEING INTENSELY QUESTIONED WITHIN THE FEMINIST MOVEMENT

# THIS WAS NO TIME FOR MEEKNESS

the feminist movement because it might scare men away looked at her and believed maybe it wouldn't be a problem.

A lot of lesbians, though, were involved in the second wave, such as Pauli Murray, who had helped kick the whole thing off. In this time of liberation, they got tired of hiding and started being open about their sexuality. In June 1969, the patrons of a gay bar in **GREENWICH VILLAGE** fought back when the police raided the place, kicking off the **STONEWALL RIOTS.** This was no time for meekness.

Betty Friedan, unfortunately, was unable to accept this and was furious that members of NOW were being public about being lesbians. She was terrified it would hurt the cause and famously referred to them as the **LAVENDER MENACE.** Prominent NOW members quit over her unbending homophobia, and she lost some of her stature as the time of revolution continued. A group of amused lesbian feminists did kind of like the power that the phrase Lavender Menace implied and adopted it as the name of their organization, emblazoning it on lavender T-shirts they wore to protest.

Even with this turmoil, NOW, under Friedan's leadership, did manage to organize something pretty spectacular.

As the fiftieth anniversary of the passage of the **NINETEENTH AMENDMENT** approached, they knew they needed to take dramatic action. The idea of a strike took hold, an event that would demonstrate the importance of women to the workings of society and draw press attention. The plan was to march

down FIFTH AVENUE in NEW YORK CITY. Friedan asked the city to close the street for them. The city refused, scoffing at the idea that anyone would show up to such a thing.

But NOW scoffed last.

The march was planned for five in the evening so working women could join after they were done for the day. That proved to be an incredibly smart plan. Women left their offices around Manhattan and poured onto Fifth Avenue—so many that they closed Fifth Avenue themselves, with police unable to confine them to one lane. Some twenty thousand women marched down Fifth Avenue to BRYANT PARK, where they listened to speeches and basked in their success. They knew then that this really was a movement.

# HEAR US ROAR

## 1971–1973

**THERE'S REALLY ONLY ONE THING** you need to know to understand how cool and mainstream feminism was in the early 1970s.

On January 18, 1973, the **DINGALING SISTERS,** an in-house singing group on the *Dean Martin Show*—yes, THAT Dean Martin—appeared wearing amazing shimmery bell-bottomed pantsuits with enormous feathery pom-poms on the sleeves and sang the feminist call to arms, "I Am Woman."

This was not a gag, either. They were SE-RIOUS, despite their required showgirl smiles. They commanded the stage, charging forward, stepping with conviction, strong and invincible. The soloist in the number was *JAYNE KENNEDY,* who went on to an incredible, groundbreaking career, and the camera moved in for close-ups when she talked about wisdom born of pain. Her hair was at least styled to look natural, done up in an afro with a braid headband and maybe just a little bit of straightening on the front. This, of course, was a big deal. Kennedy was an African American woman presented as desirable and glamorous on a television program hosted by one of the **RAT PACK,** and her hair wasn't straightened. The early seventies were magical.

The video clip ends with each sister—Kennedy, *HELEN FUNAI, MICHELLE DELLAFAVE,* and *LINDSAY BLOOM*—getting a turn at a close-up, staring defiantly and proudly into the camera as she sang the words **"I AM WOMAN"** over and over. When you learn that this act was sandwiched between **DEAN** and **STEVE LAWRENCE** doing a bigamy sketch

and a rousing "Take Me Out to the Ballgame" medley with the whole cast and the two guest stars, it makes the whole thing even more amazing. The hope and confidence in the future that comes through is so intoxicating that it's easy to forget what happens later. But we'll get to that.

Right now we need to celebrate the remarkable feminist cultural explosion of the early seventies.

Yes, behind-the-scenes legal work was still happening. *RUTH BADER GINSBURG,* already considered one of the finest legal minds in the country, founded the **WOMEN'S RIGHTS PROJECT** at the **AMERICAN CIVIL LIBERTIES UNION** (ACLU) and started knocking down gender discrimination right and left with a fervor that would make her notorious.

No-fault divorce was legalized, meaning no evidence of an affair or other misdeeds was needed to end a marriage; the two people in the marriage simply had to mutually agree to end it. Divorce rates shot up. This was, of

course, a mixed bag, as any kid who grew up in the seventies could tell you. The social and legal systems weren't yet set up to handle the repercussions, and things got sort of chaotic. As is still the case, divorce could be devastating financially for a woman, particularly if she was left to raise the kids on her own.

Still, it was empowering for a lot of women just to know that they were able to walk away from the domestic sphere. There was a moment of reckoning in a lot of marriages. Some survived, some didn't.

When **MARY TYLER MOORE** decided to produce a show in which she would star as a

single woman, it had to be made clear in the first episode that her character had broken off an engagement with a schmucky doctor, and was not divorced from the beloved DICK VAN DYKE. Specifically centered on a single woman, MARY RICHARDS, whose primary focus was a career that she loved, the show was aimed at women around the country who were trying on this new possibility. The title sequence started with clips of the character anxiously but determinedly driving into her new life, with the classic theme song echoing the concerns of so many women in 1970s:

♪ *How will you make it on your own?*
*This world is awfully big, and girl,*
*this time you're all alone* ♪♪♪

It concluded with the reassuring "YOU'RE GONNA MAKE IT AFTER ALL," sung twice for emphasis. Then we fade in to Mary Richards's world, with its close-knit workplace, gruff but encouraging boss, and cool apartment with a best friend upstairs. The job, working for a TV news show, is interesting and challenging and allows her to develop her skills and advance up the ladder. Over the course of seven seasons, we watch her grow from a nervous young woman into a competent professional, and though she dates a LOT of men over the years, and ends up in a happy romantic partnership with someone who treats her as an equal, she never marries, by choice.

The show was an idealized portrayal of a single woman's working life, but no more idealized than most television shows about men's working lives. Moore had, after all, starred on the *Dick Van Dyke Show*, which portrayed a work life even more fun than the newsroom at WJM. Like her previous show, the *Mary Tyler Moore Show* also explored issues of the day like equal pay, White male privilege—few have ever been a greater example of White male privilege than TED BAXTER—and the day-to-day realities of being a woman in the world. But funny. Really funny. Women whose single lives were less ideal appreciated the chance to visit with Mary Richards once a week.

In an early episode, Mary's scrappy best friend RHODA is shown reading a copy of *Ms.* magazine. Founded in 1971 by GLORIA STEINEM, the best-known feminist leader of the time, and DOROTHY PITMAN HUGHES, an organizer and activist in New York's Black community, the magazine was conceived as an alternative to the women's magazines of the time that were owned and controlled by men, which devoted a lot of pages to fashion and housekeeping. *Ms.* focused on politics and social issues filtered through a feminist lens and devoted space to stories that were considered tangential by the male editors and publishers of other news magazines.

For years, the magazine's most difficult task was finding advertisers that weren't the

## "YOU'RE GONNA MAKE IT AFTER ALL"

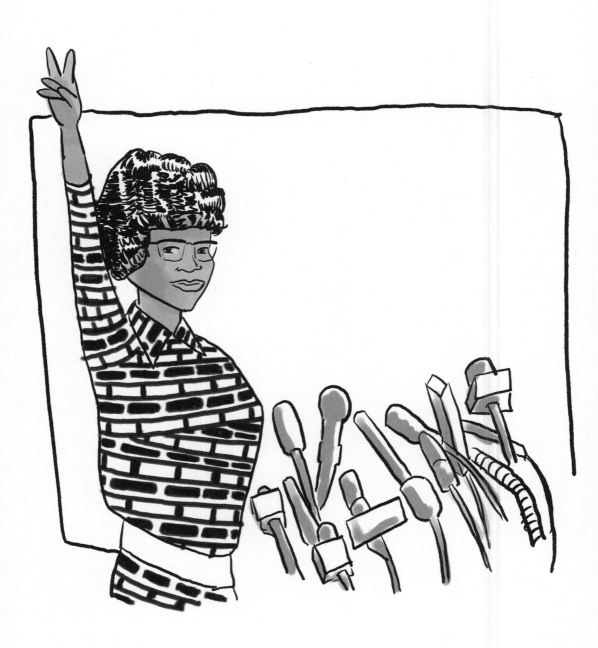

> **"IF THEY DON'T GIVE YOU A SEAT AT THE TABLE, BRING A FOLDING CHAIR"**

underestimated her. In 1968, using the slogan "Unbought and Unbossed," she was the first Black woman elected to **CONGRESS.** In 1972, she decided to run for president. As she put it, "If they don't give you a seat at the table, bring a folding chair." Although she was serious, and truly would have been a hell of a president, few others took her seriously. Prominent White feminists backed her at first, but not seeing a possibility of her winning even the nomination, they hedged their bets by also backing more conventional candidates. At the convention, though, to honor her bravery and accomplishment, several of the candidates who also had no chance of winning the nomination threw their delegates to her. It didn't put her over the top, but it showed her the respect she had earned.

traditional women's magazine advertisers, like makeup lines and fashion producers, who often expected strict control over editorial content and were economically dependent on shaming women about how they looked.

Other companies resisted marketing to women, thinking it would dilute the seriousness of their brand, or simply refused to see themselves as producing products for women. Steinem has often told of approaching auto companies armed with statistics about the growing number of women buying cars on their own to ask them to produce ads for the magazine. Over and over, male auto executives responded, "Women don't buy cars." Even with the numbers laid out in front of them.

**SHIRLEY CHISHOLM** saw future possibilities more clearly. A skinny Black woman in glasses, she had a powerful charisma and brilliant brain that overpowered anyone who

*"UNBOUGHT AND UNBOSSED"*

Also looking to the future, **MARLO THOMAS,** former star of the very first TV show to portray a happily single woman, *That Girl,* produced a feminist kids album *Free to Be . . . You and Me* in 1971. The gentlest possible feminist propaganda, the album pulled in some of the country's most popular entertainers to talk about gender roles, sharing work, and feelings. **ROSEY GRIER,** the football player, encourages boys to cry in one of the most touching songs ever recorded. **ALAN ALDA** joins Marlo Thomas to tell stories of a boy who wants a doll and a princess who doesn't want to marry right away. **DICK CAVETT** reads a poem about

trying to determine his dog's gender based on plumbing skills, **DIANA ROSS** sings about the oppressive exceptions of gender roles, and **CAROL CHANNING** lets kids know "Your mommy hates housework, your daddy hates housework, and I hate housework, too. And when you grow up, so will you."

The album sold half a million copies in its first year, and the project was expanded into a TV special two years later, with the same songs and poems and stories plus added content. Copies of the show were made available to school systems, meaning that every single child in certain liberal enclaves grew up knowing about William, the boy who wanted a doll.

As women continued to roar—in numbers too big to ignore—two major political shifts occurred.

The first came from the **SUPREME COURT.** Whereas **BIRTH CONTROL** had been fully legal for almost a decade, termination of a pregnancy was still illegal in most states, meaning women were still having to go underground if they wanted an **ABORTION.** Performed outside of hospitals, and usually with limited medical standards and no aftercare, illegal abortions were dangerous and often deadly. In Chicago, the women-run **JANE COLLECTIVE** organized to perform safe underground abortions, but it always ran the risk of arrest, as did the women terminating their pregnancies.

## AS WOMEN CONTINUED TO ROAR—IN NUMBERS TOO BIG TO IGNORE— TWO MAJOR POLITICAL SHIFTS OCCURRED

At the same time, in states where abortion was legal, women could openly access safe abortion services performed by doctors and receive professional care afterward.

Seeing the radical difference that this open access made in women's lives, activists began to push for full legalization. State-based activism sought to turn over the laws on the books but also court cases were pursued in the hopes of taking the issue to the Supreme Court.

Finally, in 1973, *Roe v. Wade,* a case in which a young woman was suing the state of Texas for access to an abortion, was heard by the justices. Citing privacy rights, the court ruled that the government should not have jurisdiction over a woman's health decisions, and, therefore, states could not prevent access to abortion in the first and second trimesters. The third trimester, when a woman carries a more fully developed fetus, was considered a grayer area, and the justices left it open to the states how to regulate that stage, when pregnancies are rarely terminated, and then only when a woman's life or

**SEEING THE RADICAL DIFFERENCE THAT THIS OPEN ACCESS MADE IN WOMEN'S LIVES, ACTIVISTS BEGAN TO PUSH FOR FULL LEGALIZATION**

health is in danger or in other extreme circumstances.

Beyond the specific expansion of reproductive access that came out of the ruling, it also made a statement about who should be in charge of a woman's body, making it plain that it should be the woman herself. It would seem to go without saying, but the highest court in the land still needed to decree this.

A year earlier, the legislative and executive branches of the federal government had made a similarly profound statement: fifty years after first being introduced in Congress, the EQUAL RIGHTS AMENDMENT passed the House and Senate! By huge margins! Then it was signed by PRESIDENT NIXON, who was clinging to office by his fingernails.

Altered slightly from *ALICE PAUL'S* original version, it now read simply,

Equality of rights under the law shall not be denied or abridged by the United States or by any State on account of sex.

The coolest part: Alice Paul was STILL ALIVE and got to witness her amazing accomplishment.

The amendment was then sent for ratification to the states, which competed to be the first to ratify. Hawaii won the honor. The amendment needed approval by thirty-eight states to be fully ratified. The House had passed a bill giving the amendment of seven years to get all the necessary state ratifications. But whatever. How could it be a problem? Look at how excited everyone was! I mean, the Dingaling Sisters had sung "I Am Woman" on the *Dean Martin Show*! We were golden, right?

Get yourself a soothing beverage before turning to the next chapter.

# MALAISE

## 1974-1979

### THE ENTHUSIASM DIDN'T LAST.

Not that progress didn't continue—legislation was written and cases were filed. *Ms.* was still being published and women were still entering the workforce in great numbers and with better opportunities. It's just that the giddy moment didn't last.

Giddy moments never do.

**WATERGATE** soured everything and the economy went soft.

The **VIETNAM WAR** had ended unsuccessfully and horrifically, adding to the impression that all those lives had been lost for nothing.

The oldest boomers were just about to hit their thirties, and they were getting all introspective and wistful, and they started at-

tending seminars to make their lives more meaningful.

It was just a weird time.

Still, there was some fun stuff.

**BETTY FORD** had become **FIRST LADY** after **NIXON** boarded his last chopper out, and she was a real pistol. She was an unabashed feminist and promoted the **ERA** heavily as it made its way through the states, and got her husband in on the act, too. She was also funny and entertaining. It turned out it was kind of because she had a drinking problem, but she ended up being a powerful, outspoken advocate for addiction treatment, so that was pretty great.

Movies had cool, swaggering, wisecracking women in them, like **MARGOT KIDDER** as **LOIS LANE** and **CARRIE FISHER** as **PRINCESS LEIA**.

*DISCO!* Disco was fantastic!

And **JACKIE KENNEDY** was back after years in solitude. She'd married a Greek shipping tycoon who was happy to provide her with a life on a quiet private island and she'd become **JACKIE ONASSIS.** When she eventually grew tired of the island and wanted to venture out into the world again, her husband resisted, so she ditched him and determined never to marry again. She became **JACKIE O,** walking the streets of Manhattan in giant, dark, glamorous sunglasses, working as an editor, and occasionally hanging out at **STUDIO 54.** It was glorious!

But now we have to talk about the crushing of the ERA.

Remember how excited everyone was about the ERA? It turns out it wasn't really everyone. The weird thing is that lots of women were against it. A lot of women had been against the NINETEENTH AMENDMENT, too, but we don't think about them much now because they didn't manage to stop it.

Women stopped the ERA. They didn't do it alone—plenty of men standing off in the wings helped—but the women were the face of it. One woman in particular.

### PHYLLIS SCHLAFLY.

Schlafly had honed her political skills in the sixties fighting to uphold segregation. She didn't talk about it in the seventies in her anti-ERA speeches because it wasn't thought of as a nice thing to say out loud anymore, but she had never changed her mind.

She was sharp, quick in a debate, and she could be funny. She was great on TV.

Much of her life was spent on the road away from her husband and kids, but she was determined that other women should stay at home to tend to their families.

A real piece of work she was.

In 1972, when it was approved by the House and Senate, and signed by Nixon, the ERA was ratified by twenty-two states. It needed thirty-eight for full ratification, so it seemed to be well on its way. The next year, eight more states ratified.

*REMEMBER HOW EXCITED EVERYONE WAS ABOUT THE ERA? IT TURNS OUT IT WASN'T REALLY EVERYONE.*

Then things ground to a halt. Five more states ratified between 1974 and 1977, and then nothing. The House-mandated deadline—March 22, 1979—was coming closer and closer as the once-heady momentum stagnated. As time ticked on and the number held at thirty-five, it became clear it wasn't going to make it in time.

In 1978, Representative **ELIZABETH HOLTZMAN** of New York introduced a joint resolution to extend the deadline to June 30, 1982. Though the resolution passed in the House and Senate, it was by less than a two-thirds majority.

In the 1976 general election, both the Republican—Betty Ford's husband—and the Democratic candidates had pledged their support of the ERA. The Democrats won because the Republicans were still too tainted by WATERGATE, and CARTER was then called upon to honor his pledge. Concerned that the less-than-two-thirds majority made the deadline extension too easily disputed, supporters asked the president to sign it to seal its authority. This was not the usual procedure for a joint resolution, and the president was careful to note that as he signed, but he did sign. This gave ERA supporters another three years to combat the backlash.

The promise of the domestic sphere was that it provided protection. White women could give up full freedom and autonomy,

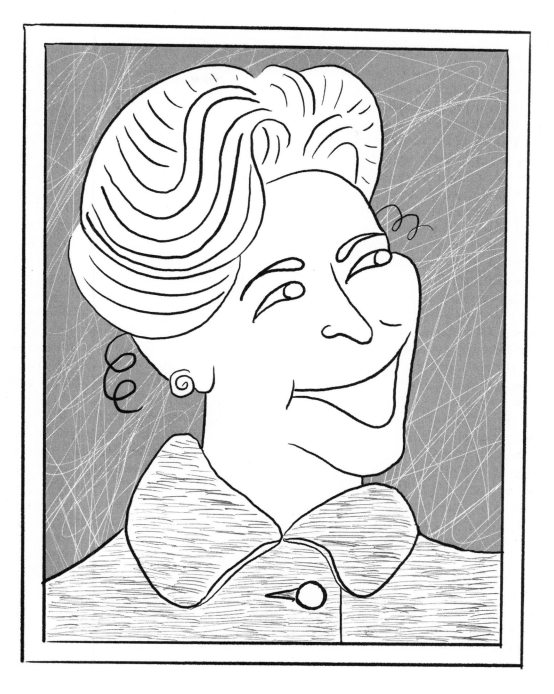

but in exchange they would be kept safe from the world outside, which they were told was full of dangerous, unfamiliar men, the most terrifying of which were Black men.

This framing had been used not only to get some White women to resist the Nineteenth Amendment at the turn of the twentieth century but also to gain support for it from others, with the argument that their votes would be essential to preserve a White majority of voters in the Southern states. The temperance movement had used it, too, stoking fears of drunken newly freed Black men preying on White women.

Schlafly and her segregationist ilk depended on these fears, which had shaped the laws creating separate schools, waiting rooms, water fountains, swimming pools, and so on, as a way to extend the protective domestic sphere into public spaces that would be used by White women and their children.

With the ending of on-the-books segregation, the one place left that White people could dependably keep free of unwelcome Black people—those who weren't there to cut the lawn or tidy the rooms—was their home.

Schlafly, savvy about public messaging, didn't explicitly bring up race when she campaigned

> SCHLAFLY AND HER SEGREGATIONIST ILK DEPENDED ON THESE FEARS

against the ERA, but she did talk about the need to preserve safeguards for women. She warned that chaos would ensue if the ERA was passed, with women forced from their

## "CAREFUL, PHYLLIS, YOUR SHEET IS SHOWING."

homes, no longer allowed to care for their children, exposed against their will to the unsavory life of the public sphere.

It was easy to see past the coded language. GARRY TRUDEAU demonstrated this in his daily comic strip, *Doonesbury*, which for two weeks in 1977 skewered Schlafly and her fellow anti-ERA women. The comic strip's readers had followed JOANIE CAUCUS in her journey from frustrated housewife to single mom to lawyer to congressional aide. When her boss and mentor, Representative LACEY DAVENPORT, comes down with a fever, she asks Caucus to debate Schlafly in her place.

Caucus is intimidated, knowing how Schlafly claims the pro-family, pro-God, pro-life, pro-America position, leaving her opponents to look like they are against those values. Midway through the debate, though, as Schlafly launches into her argument for safeguards, Caucus quips, "Careful, Phyllis, your sheet is showing."

Schlafly had more specific warnings about the ERA. She would get worked up about the possibility of men and women being forced to share public bathrooms, for instance. She was, in fact, right about some of the things the ERA could bring about:

same-sex marriage, the opening of the draft to include women, the Constitutional backing of abortion rights.

What she seemed to miss, or at least what she didn't mention, was that these things could all be achieved through separate legislation and court rulings. The ERA was simply a way to smooth that process by enshrining gender equality as a constitutionally recognized principle.

Feminist activists knew this and had not put all their eggs in the ERA basket. **RUTH BADER GINSBURG** was still fighting case by case in the courts; **NOW** was still pushing legislation introduced by feminists the women's movement had helped get elected.

The country had changed. The postwar era of an expanded middle class made up of White nuclear families couldn't still exist even if the social changes of the sixties hadn't happened. International conditions and economic realities were different.

Fighting the ERA might have felt good for those who were terrified as they watched the guarantees they had known slip away, but its defeat wouldn't bring those guarantees back.

The world was moving on without them, as evidenced by the staging of the **NATIONAL WOMEN'S CONFERENCE** in **HOUSTON** in 1977. The **UNITED NATIONS** had held an international women's conference in **MEXICO CITY** in 1975, the **INTERNATIONAL YEAR OF THE WOMAN.** Countries with delegates in attendance were charged with holding their own conferences. In 1977 the president created a commission to put together a national women's conference, to be paid for with $5 million allocated by Congress.

To head it up, the president called on **BELLA ABZUG,** the well-known firebrand state rep from New York, and **CARMEN DELGADO VOTAW,** the Puerto Rican activist and community organizer, both of whom had attended the Mexico City conference.

A series of state conventions was held through the winter, spring, and summer, open to all females sixteen years and older, and delegates were chosen to attend the national conference in Houston in November.

It's kind of amazing that it was all put together so quickly, but this is what women do.

There were 2,005 elected delegates at the conference representing all fifty states plus six US territories. Another 13,000 to 20,000 (accurate counts were tricky) people showed up to observe, and all but a handful of them were women.

A touching opening ceremony featured a torch that had been carried by runners from **SENECA FALLS** over the weeks leading up to the conference. It was presented to former First Ladies **LADY BIRD JOHNSON** and **BETTY FORD** and current **FIRST LADY ROSALYNN CARTER** along with a **DECLARATION OF SENTIMENTS** written by **MAYA ANGELOU** that echoed and built on what **ELIZABETH CADY STANTON** had written in 1848. The declaration had been signed by thousands of people as the torch made its journey south.

Though this was a government-sponsored conference, any resolutions made over the course of the four days would not be legally binding. Still, it was a chance to collectively

put together a platform of issues to work on in the years ahead. All the big players were there. Basically, any feminist mentioned in the book so far who was still living was there, along with thousands who haven't been mentioned, some who had already been working on women's liberation for years and some who were just starting out.

There were twenty-six planks, and only the one in favor of equality in credit was approved unanimously. All the others were debated vigorously, with the discussion getting particularly heated over the planks supporting access to abortion, decriminalization of homosexuality, and the Equal Rights Amendment. These three planks were ultimately ap-

proved, though the intense, angry response from those against the abortion plank was a harbinger of battles to come.

Indeed, though the ultimate platform was quite progressive, there was discontent among some of the more conservative delegates. In the article "Women's Conference Approves Planks on Abortion and Rights for Homosexuals," the *New York Times* reported, "Sarah Lore of Normal, Ill., said bitterly on the convention floor, 'This is a sham. This conference is run by lesbians and militant feminists.'"

Across town, Schlafly had put on an alternative women's conference of her own, nearly as well attended, in support of "traditional

values." Though some at the time mocked it as a stunt, in a way it was more successful.

Right after the conference, the deadline extension for the ERA was passed and signed, but neither the administration nor Congress took any other real action in support of the resolutions agreed to at the conference.

In 1975, the film *The Stepford Wives* was released. Based on a novel by IRA LEVIN, it depicts a town in which all the wives seem only to cook and clean and shop and smile. A bohemian newcomer is baffled, and then horrified, when one of the only friends she makes changes overnight into one of them. She comes to discover—by stabbing her friend with a kitchen knife—the dutiful wives are all robots made by the husbands to be more docile replicas of their human wives, and she tries to escape. At the end of the movie, alas, her husband, who seemed to be happy with his complex and challenging human wife, is shown picking up his smiling robot wife at the supermarket, and we understand that he secretly wanted this all along.

The film was a perfect reflection of the paranoia feminists were feeling as the men in charge talked a good game but didn't seem to back them up when it was time for action. Their suspicions that a lot of these seemingly supportive men had always secretly rooted against feminism were about to be confirmed.

Meanwhile, a cultural revolution was brewing in the dive bar music venues of New York and Los Angeles. PUNK ROCK—loud, rough, and deconstructed—was a reaction to the bloated arena event rock and tangerine leisure suits of the seventies. Bands spit in the face—literally—of pleasant prettiness and pretension. This would be the music of the underground, and women like *LYDIA LUNCH* and *EXENE CERVENKA* charged at the vanguard, stabbing Stepford right in the heart.

## CHAPTER 10

# MEN DON'T PROTECT YOU ANYMORE

## 1980–1991

**WITH REAGAN'S OVERWHELMING WIN,** the White patriarch reestablished mythic dominance. He was divorced, and he never went to church, but the Moral Majority saw him as more religious than President Carter, who had been married to Rosalynn since they were practically kids and was an active and evangelical member of the Baptist church who prayed several times a day.

REAGAN looked the part of someone who should be in charge of things, and as a result had been put in charge of things, like the Screen Actors Guild and the state of California. He was tall and carried himself with the confidence of a man who'd been very handsome in his youth, and still had that twinkle in his eye. He spoke in the Standard American he'd learned as a radio announcer but with a slight nod to the western drawl he'd picked up playing cowboys. He was Rex Stetson writ large.

In fact, ROCK HUDSON himself hung out in the president's circle. While Ron and *NANCY* had never risen above B-movie status, their friendships brought Old Hollywood glamour to the White House. Reagan's inauguration was the most expensive in history, with candlelit dinners and events that were described as "lavish galas" in the newspapers. Star-studded, too. Everything was going to be star-studded in the new Silver Screen America. No more scruffy hippies and scary Panthers. The eighties were going to be a time of champagne wishes and caviar dreams, to borrow the tagline from one of the decade's most popular shows.

The anti-ERA women were thrilled, of course. They could recognize themselves in the adoring Nancy gazing up at Ronnie in deference and delight on the public stage, saving her forcefulness for the behind-the-scenes work of building her man's home life and supporting his career.

The administration, however, could not completely ignore women's advances. In 1981, President Reagan nominated *SANDRA O'CONNOR* for the SUPREME COURT, and she was confirmed, making her the first woman to serve. While she was believed to be a strict "traditional values" type at the time, she later proved to be an important voice for reproductive rights and a few other issues that had recently been deemed radical by the Republican Party.

## THE ADMINISTRATION, HOWEVER, COULD NOT COMPLETELY IGNORE WOMEN'S ADVANCES

Just three years after a Republican First Lady, *BETTY FORD*, gave a speech at the feminist NATIONAL WOMEN'S CONFERENCE in Houston, the GOP dropped passage of the EQUAL RIGHTS AMENDMENT from its party platform. Considering that it had been the first party to openly support the ERA, all the way back in 1940, this indicated a sea change. The proposed amendment still had two years until its extended deadline expired, but its prospects looked bleak.

ILLINOIS, home state of *PHYLLIS SCHLAFLY*, was to be the scene of its undoing. On June 30, 1982, the final deadline for ratification, the State House was the backdrop for massive and dramatic demonstrations. Activists, many of them days into hunger strikes, chained themselves to the fences out front, others wrote pro-ERA messages in animal

blood on the State House floor. Schoolkids who had been brought in to watch the historic proceedings left a bit traumatized. This was the level of anger and frustration, though, as the feminist dreams and passion of the seventies seemed to be slipping away.

A vote in favor of ratification wouldn't have sealed the deal at that point—two more states were still needed to reach the minimum—but it would have given activists a reason to push for another extension. It would have given them hope.

There was no hope to be found in Springfield, Illinois, that day.

A combined push by gender traditionalists and insurance companies, which feared they would no longer be able to charge women more for their products if the ERA was ratified, garnered enough "no" votes to squash ratification, and that was that.

The news covered the defeat, of course, but did not allot as much coverage as the amendment's passage in the US House and Senate had garnered a decade before. More people than you might expect who lived through that time, and considered themselves up on current events, think the ERA was ratified and added to the Constitution.

After this point, most feminist activists turned their attention back to piecemeal advances in gender equality, which had been happening anyway even while the ERA burned out. Some, though, tended the

> THIS WAS THE LEVEL OF ANGER AND FRUSTRATION, THOUGH, AS THE FEMINIST DREAMS AND PASSION OF THE SEVENTIES SEEMED TO SLIP AWAY

embers and continued to introduce it in state legislatures year after year. JACKIE O'S brother-in-law, a senator from Massachusetts, continued to introduce it in the US Senate each year as a gesture of support.

Writers are almost legally obligated to refer to the eighties as the "GO-GO EIGHTIES." This refers not to the fabulous all-female band of the era who got the beat and needed a vacation but to the impression that everyone and everything in that decade was just go-go-going. This was not untrue. MTV made jump-cut edits cool, which led to lots of hyper pop culture.

There was also, of course, a TON of cocaine flooding the country because of various right-wing gunrunning schemes in Central America that relied on trades with drug lords. That sort of thing—cocaine, right-wing gunrunning schemes in Central America, etc.—was super hip in the eighties, and certainly added to the go-go atmosphere.

What really did it, though, what really made the eighties go-go, was the SPREADSHEET. With spreadsheets, you could not only do crazy, complex calculations quickly and easily but also plug in new numbers, and all the connected numbers would just change without anyone having to write out the whole equation again. This was, of course, ultra-useful for medical researchers and space explorers and all of those nerds, but more importantly it helped all those coked-up

traders on **WALL STREET** with their slicked-back hair make money. Serious money. Big-time money.

With the right equations on the right spreadsheets, you could plug in stock prices and related numbers and predict future potential. You could plug in the numbers of some mom-and-pop factory and in minutes discover that it was undervalued and not maximizing its profit potential. You could even charge people for your number-plugging services.

Mergers! Acquisitions! Smooshing companies together or selling them off for parts. Alter a variable and change the world.

At the same time, the new administration was slashing regulations, busting unions, cutting taxes, and dismantling government programs as its approach to the stagflation of the seventies. **TRICKLE-DOWN THEORY** was the big GOP concept, the idea being that if the government just got out of the way of businesses, everyone who ran them would get rich, and then all that richness would trickle down to other folks in the country.

Rich people did get richer. They kept getting richer. But not much changed for regular folks. The economic situation improved a little, but labor had become just another number on a spreadsheet, and it was one of the first things cut when profits needed to be maximized.

The jobs that enabled a White working-class man to pay for a house and a car on his

> ### RICH PEOPLE DID GET RICHER. THEY KEPT GETTING RICHER. BUT NOT MUCH CHANGED FOR REGULAR FOLKS.

own were disappearing, so the women who married working men and who wanted to stay home with their kids often couldn't anymore.

After all those years of hearing Schlafly tell women that feminists and feminist ideals would force them out of the domestic sphere, though, these women blamed them and those ideals for their situation, not the guys with the spreadsheets.

The postwar era had been a weird blip. Buying a house and a car had never been an option on a single working-class salary before then. Previously, women took in piece-work or laundry, or sold things from a cart, or took low-paying jobs at a factory to supplement their husband's income. Postwar feminism meant that there were better options available to a lot more women.

But not all women. The promised trickle-down effect of Reagan's massive tax cuts for the rich wasn't even trickling and was by no means making up for the government programs that had been defunded to pay for the cuts. **PUNK ROCK** had produced **POST-PUNK** and **NEW WAVE**, genres

*THE PROMISED TRICKLE-DOWN EFFECT OF REAGAN'S MASSIVE TAX CUTS FOR THE RICH WASN'T EVEN TRICKLING*

with similar rage, but with musicians who could really play their instruments. THE PRETENDERS, out of Ohio, a state that was watching its industrial base be dismantled and sold off for parts, produced furious but precise songs written by *CHRISSIE HYNDE,* their raspy and sarcastic lead singer. In "Watching the Clothes Go Round," a frantic, jumpy, anxious song, she writes as the waitress she'd been before the band took off, doing her laundry on a Saturday night and thinking about all the middle-class ass she kisses.

*Oh, I've been working hard*
*Mmm, trying to make some money*
*"Would you like sour cream*
*On your potato, honey?"*

The government benefits that White people were losing, such as government assistance with home loans, had only recently become even somewhat available to Black people. It had been nearly impossible for Black people to get a mortgage, with or without government assistance, and even if they could get a mortgage, they hadn't been able to buy homes in the suburban developments that had sprung up across the country.

Without that ability to build capital, Black families had been left behind economically. In the late sixties and through the seventies, activists made progress getting laws passed to create some approximation of equal opportunity, including the FAIR HOUSING ACT in 1968. Through a lot of effort, things had begun to change.

## THESE CHANGES, UNFORTUNATELY, WERE OFTEN MET WITH VIOLENT BACKLASH

These changes, unfortunately, were often met with violent backlash. The question of who was allowed to have a domestic sphere continued to dominate American life.

When he had first run for president in 1976, Reagan seized on a news story about a Black woman who had managed to game the system. *LINDA TAYLOR,* a con woman in Chicago, had racked up $150,000 a year using aliases and false addresses to collect a variety of government benefits. The *Chicago Tribune* dubbed her the WELFARE QUEEN, and Reagan ran with that moniker. It would eventually become shorthand to refer to all Black women who received government benefits.

Although the vast majority of people in the country receiving food stamps, welfare assistance, and other government subsidies were White, the repetition of the rare stories like Linda Taylor's started to give the impression that Black people were living high on the hog off the taxes paid by decent, hardworking citizens.

That Linda Taylor—an actual singularly horrific and scary person who did far worse in her lifetime than commit welfare fraud—was caught, convicted, and served prison time for fraud made no difference. Her story played into the stereotype of Black people as

lazy and not to be trusted. When Reagan and the rest of the GOP talked about cutting government subsidies, they could say it was to stop giving handouts to people like Taylor.

This framing of the issue that recast government assistance as a Black thing added a layer of shame for White people who were also collecting benefits. One benefit of being White was supposed to be that you had separate, better spaces and support. The minor progress made in distribution of benefits had ruined that.

The promise of the Reagan years was a return to the fifties, but not the fifties of high taxes, big government, and federal investment. All the Republicans had to offer was a return to the codified social divisions that had existed before the upheavals of the sixties and seventies.

The weekly evening soap *Dallas* bridged the seventies and eighties with its tale of good and evil brothers competing to be the patriarchs of their Texas oil family. This trials and tribulations of the superrich formula was expanded on by *Dynasty* in which a dutiful wife competes with a scheming ex-wife for the attentions and fortunes of an uberrich silver fox. At one point, the two women wrestle each other in a decorative pond in one of the campiest moments in television history. Capitalizing on the nostalgia of casting an old-timey movie actor as president, the show's creators brought in some classic stars of their own, including the fabulous **JOAN COLLINS** as the evil ex. Joan's sister, **JACKIE COLLINS,** had drawn on observations

of her sister's celebrity life to write *Hollywood Wives,* her fabulously tawdry novel about the sexual secrets of Hollywood.

In season five, **ROCK HUDSON** was brought in to play his usual dashing White patriarch role, but he had a sexual secret of his own. Though Hudson's homosexuality had been a somewhat open secret among his friends, he was otherwise very carefully closeted. His agent once gave a reporter damaging stories about two other celebrities simply to keep Hudson's secret from going public. The agent then set his unsuspecting secretary up with Hudson and got Hudson to propose to her. She married Hudson believing it was real and was devastated when she later learned that she was just a decoy.

All the gay leading men in Hollywood were in the closet. They had no other option.

### ALL THE GAY LEADING MEN IN HOLLYWOOD WERE IN THE CLOSET. THEY HAD NO OTHER OPTION.

In 1982 at a White House press briefing, a reporter asked the press secretary, **LARRY SPEAKES,** whether the administration was at all concerned about the spread of a deadly new disease called **AIDS** that was killing gay men. Speakes joked that maybe the reporter was gay for asking and continued to joke about the matter until the whole room was laughing, including the reporter who had asked the question. Speakes concluded by saying

that, no, the administration hadn't been paying attention to this AIDS thing at all. At that point, more than six hundred men had been infected, and all were dead or soon to be.

Thousands died as doctors scrambled to find cures, treatments, or even how to prevent it. With no government research money, it all had to be done with raised funds, which were difficult to come by for a disease with so much stigma attached.

Men with AIDS were often abandoned by their families when they were diagnosed. In addition to the groups that gay men rapidly put together to provide care and information to their community, women's collectives, experienced at organizing to provide needed health care, stepped in to help. They often bridged the rift that had opened between gay communities and lesbian communities.

Viewers of *Dynasty* noticed that Rock Hudson was looking a little worse for wear on the show, but the producers edited out moments when he slurred or forgot his lines, so there was no great alarm at first. Eventually, though, his debility became too hard to hide and he was written out of the show.

Then his old friend **DORIS DAY** was suddenly back in the spotlight. Her name was referenced in the song "Wake Me Up Before You Go-Go," an enormous hit by the duo **WHAM!** who were so obviously a couple in the video, though everyone had to pretend they weren't for a long time. The mention led to little MTV news items for the kids about who Doris Day was, and soon she was offered a variety show.

At the press conference announcing the new show, Hudson, whom she planned to have on as a regular guest, accompanied her. His appearance shocked people. With no editing, his slurred speech was obvious, and he was even more gaunt than he'd been on *Dynasty*.

Again, it was never really a secret when a man in Hollywood was gay, so whispers began about what was going on. At first, his publicists denied that he had AIDS, though he had soon after flown to France in the hopes that treatments there would help. After a week, he publicly confirmed that he had the disease, officially outing himself and shaking up perceptions of who gay men were.

While desperate in France, he had reached out to his old friends Nancy and Ronald, now residents of the White House, in the hopes they could get him access to a healthcare system there that restricted foreigners. Fearing it would look like giving special treatment, but also not wanting to be closely associated with this stigmatized situation, they declined.

> **THOUSANDS DIED AS DOCTORS SCRAMBLED**

*REAGAN DID NOT MAKE
A MAJOR SPEECH ON THE
AIDS EPIDEMIC UNTIL 1987,
BY WHICH POINT MORE THAN
TWENTY THOUSAND PEOPLE
HAD DIED OF THE DISEASE*

A few months later, on October 2, 1985, Hudson died at home in LA.

Reagan did not make a major speech on the AIDS epidemic until 1987, by which point more than twenty thousand people had died of the disease.

ACT-UP, an aggressive AIDS advocacy group, organized the same year. They took as their slogan SILENCE = DEATH and as their symbol the upside-down pink triangle that the Nazis had forced homosexuals to wear while they waited in concentration camps to die. The slogan spread throughout New York via mimeographs made by gay assistants who basically ran the fashion and entertainment industries. It served as a warning to gay men that the time to speak up was now.

Not that people weren't already challenging gender roles and sexuality. The two biggest comedy hits of 1982 jabbed at gender pretty deeply. In *Victor/Victoria*, **JULIE ANDREWS**, breaking out of her nanny typecasting, plays a starving singer who pretends to be a man so she can work as a female impersonator. In *Tootsie*, DUSTIN HOFFMAN, who in real life was known for womanizing and, we now

know, sexual harassment, plays an out-of-work actor who pretends to be a woman to land a role on a soap opera.

Between the laughs, both films show their characters learning through experience what it is to live as the other gender and the freedoms and limitations that come with the identity. *Victor/Victoria*, focuses in particular on the lives of gay men, while *Tootsie* examines the ways in which women were humiliated and abused by men in their daily lives.

The revenge fantasy *9 to 5* had explored that theme a couple of years earlier. Three women who work at the same office accidentally kidnap their awful, lazy, sexist boss and then remake the office into a feminist's dream—they paint the walls with warm colors, set up a day care, introduce job sharing, provide addiction counseling, encourage personalized desk decor, among other things—with profitable and productive results. All the changes they make were changes to work life that the women's movement had been pushing for decades, and it's depressing now to watch and know that almost none of them became a reality on a wide scale.

*ALL THE CHANGES THEY MAKE
WERE CHANGES TO WORK LIFE
THAT THE WOMEN'S MOVEMENT
HAD BEEN PUSHING FOR DECADES,
AND IT'S DEPRESSING NOW TO
WATCH AND KNOW THAT ALMOST
NONE OF THEM BECAME
A REALITY ON A WIDE SCALE*

Kids today are shocked when they learn that *MTV* stands for **MUSIC TELEVISION**. It's now become almost exclusively a reality TV channel. When it started, though, it was all music, which became economically feasible when television stations started broadcasting over cable. Stations could be niche outlets. MTV changed the music industry. Though some music fans were upset to see the shift to music videos over songs themselves, it was one of the amazing aspects of the new pop music scene.

Edgy and experimental musicians were suddenly being heard by mainstream audiences because they had made a cool video. This eventually resulted in an interesting variety of music, though at first MTV focused primarily on rock music, which was mostly created by White people. **MICHAEL JACK-SON** changed that when he released the revolutionary **"BILLIE JEAN"** video in 1983 and MTV had to air it. It was, of course, an enormous hit, and MTV started changing its programming. Soon the sounds of R&B, new wave, and synth-pop were in regular rotation. Singers with particularly striking looks had an edge, and quickly *CYNDI LAUPER, ANNIE LENNOX, BOY GEORGE,* and other artists pushing the boundaries of gender and fashion were huge stars. This shift harked back to glam rock, but that had usually existed just outside the mainstream in the United States.

*EDGY AND EXPERIMENTAL MUSICIANS WERE SUDDENLY BEING HEARD BY MAINSTREAM AUDIENCES BECAUSE THEY HAD MADE A COOL VIDEO*

MTV actually was the mainstream.

*JANET JACKSON,* Michael's sister, brought a tight militancy to dance music with her album *Control*, with songs reflecting on her life as a Black woman and what she wouldn't put up with anymore. "Got my own mind / I want to make my own decisions" she sings in the title song, and in the most iconic moment on the album, she declares,

*No, my first name ain't baby*
*It's Janet*
*Miss Jackson if you're nasty*

*MADONNA,* who always went by the same name but refused to be pinned down by any image for very long, merits a whole chapter of her own. She made her own pleasure the centerpiece of her sexuality and brought us all along as she wrestled with womanhood and celebrity and power. For a while there, she ruled the world.

The eighties saw the birth of two other massive woman-led media empires.

*OPRAH WINFREY* was born to a single mom in rural 1950s Mississippi. Her mother moved north, leaving her to live with her grandmother in intense poverty for her first six years. She often wore potato sacks as dresses because her grandmother couldn't afford other clothes. After that, she went north to be with her mother for a few years, then, when her mother wasn't able to

handle her load, to Nashville to live with the man who was said to be her biological father but who maybe wasn't. Then she went back to her mother, then back to the man who was a father to her. It was a difficult and chaotic childhood filled with neglect, trauma, and abuse but also lots of joy, love, and support. She was recognized as an exceptional and intelligent person early, which provided her with opportunities that others in her situation did not have, and she was able to grab hold of those opportunities and become the powerful and influential person she is today.

We know all this because Winfrey has talked about it. No one is more dedicated to the idea that sharing our stories is essential and empowering, particularly for women. As a Black woman, she has been able to trade on the comfort White women traditionally felt with the Mammy archetype, but she was able to do that in the eighties without having to actually perform the role of a mammy.

She did, however, show us the White cruelty that produced dutiful, subservient mammies when she played **SOFIA** in the film version of *The Color Purple*, her first attempt at acting. The novel by ***ALICE WALKER,*** a massive best seller, depicted the lives of Black women in rural Georgia in the early twentieth century through a series of letters written by **CELIE,** an outwardly timid young woman quietly holding onto her sense of self as her life takes her from one abusive man to the next. Though slavery has, of course, been made illegal, the sharecropping system and Jim Crow keep the Black population of Georgia strictly controlled. Sofia, who Winfrey portrays in the film, is assertive and tough and often scornful of Celie's meekness. She fights and fights and fights and fights, never giving an inch of herself up.

Then she says no to a White woman, the mayor's wife, who wants to hire her to watch her children.

Imprisoned for her defiance, she is beaten nearly to death and comes out broken. Where before Sofia charged through life, she now slumps, her face crooked from the blows it's taken. The light is gone. In her performance, Winfrey shows the limits of

self-actualization in a society determined to push you down.

No longer able to fight, Sofia goes to work for the mayor's wife, taking on the mammy role required of her. Celie, herself strengthened by the care of another woman, tends to Sofia, trying to soothe away any feelings of shame. She knows there is no shame in surviving.

In her real, public life, Oprah Winfrey makes it clear that she is fully equal and will not be treated otherwise, but she never pretends that isn't difficult. For her show's theme song, she repurposed *CHAKA KHAN'S* 1978 "I'm Every Woman," initially a come-on to a potential lover, into an announcement of that equality.

♪ *I'm every woman*
*It's all in me* ♫ ♪

With that message, she invited women in, whoever they were, and offered help and understanding no matter where they were on their journey. She was open about her traumas and insecurities and feelings of failure in the way women were in private with their closest friends. She brought the kitchen table into the public sphere and invited you to sit a while.

*SHE INVITED WOMEN IN,*
*WHOEVER THEY WERE,*
*AND OFFERED HELP AND*
*UNDERSTANDING NO*
*MATTER WHERE THEY WERE*
*ON THEIR JOURNEY*

*MARTHA STEWART,* on the other hand, had no time for your frailties, dammit. She expected nothing less than your very best effort. While she followed in the footsteps of domestic instructors of the past, like *FANNIE FARMER* and *LILLIAN GILBRETH,* her instructions were not about making homes more efficient or home life smoother. She wanted you to own your domestic work, to present it as an accomplishment. Her tagline about her own work was unequivocal: It's a good thing.

## "IT'S A GOOD THING"

Initially downplaying the army of assistants helping her achieve all of this perfection, Stewart communicated an expectation that all women should be able to run their homes like she did, even publishing her monthly calendar so other women could emulate her time management. Though she published curated photographs of her home and dinner parties, she was not inviting us in, as Winfrey did, just encouraging us to replicate in our own spaces what she had. She kept the domestic arts in the domestic sphere.

What is amazing about both Winfrey and Stewart is that they never pretended they weren't businesswomen. In keeping with the general eighties vibe, they unapologetically pursued money and power. They didn't hide behind a pretend partnership with a husband, like *LUCILLE BALL* did while running *DESILU PRODUCTIONS* mostly by

herself. They didn't indulge in public shows of puritanical modesty, like **MARY PICKFORD** and **JOAN CRAWFORD** had. They let us know that they were living their best life and that their career was their main focus—which seemed basically okay with people as long as these women stayed in their domestically focused areas.

The domestic sphere was still intact and was still evoked as an essential safeguard. In the 1988 presidential campaign, Vice President **GEORGE H. W. BUSH** ran against Massachusetts governor **MICHAEL S. DUKAKIS**. Earlier in his governorship, Dukakis had approved a plan that gave prisoners furloughs for good behavior. One prisoner on furlough

escaped, then raped a woman, which led to the end of the program. The prisoner, **WILLIE HORTON,** was Black and the woman who was raped was White.

During the presidential campaign, Bush authorized an ad featuring a Black male actor creeping through the shadows around a White woman's house and grabbing her from behind. The message: Dukakis wasn't up to the task of protecting White women from Black men, long the central task of the US government. Bush won the election, bringing in four more years of Republican control.

# CHAPTER 11

# COOKIES

## 1992–2008

**THE WOMEN WHO TOOK PART** in the civil rights, antiwar, women's liberation, and the many other movements of the late sixties and early seventies were now the age when men traditionally became respected authority figures. For the first time, this happened for some of these women, particularly those who participated in traditionally male-dominated fields, such as politics, journalism, and law. There were few enough such prominent women that it was a big deal when they did attain a certain status, and it was definitely a sign that the needle had moved, even if some progress had been reversed in the previous decade.

**SUSAN FALUDI'S** book *Backlash*, detailing these ways in which various forces in society had rolled back some of feminism's gains, from cultural to legal, and helped feminists refocus their efforts to move the needle back.

**TEXAS**, for instance, perhaps still feeling the ripples of the **NATIONAL WOMEN'S CONFERENCE** in 1977, was suddenly a center for women becoming big shots. That is, two women in particular.

**ANN RICHARDS** had been involved in Austin politics for decades. She was tough and smart, but as a Texas woman she also knew how to be a bit flirty when necessary. Austin was known as a wild, liberal bastion, and Richards, an unabashed feminist, was definitely of that bent. But as she got more and more serious government gigs, she made sure her hair was set and her lipstick was straight. Even those who disagreed with her could be charmed by her sharp humor and winking charm. She also made sure Texas folks knew she could handle a shotgun. She was no fool.

In 1988, as the state treasurer of Texas, she made the keynote speech at the **DEMOCRATIC NATIONAL CONVENTION** and brought

> **"GINGER ROGERS DID EVERYTHING THAT FRED ASTAIRE DID. SHE JUST DID IT BACKWARDS AND IN HIGH HEELS."**

> **"I DEARLY LOVE THE STATE OF TEXAS, BUT I CONSIDER THAT A HARMLESS PERVERSION ON MY PART, AND DISCUSS IT ONLY WITH CONSENTING ADULTS."**

the house down with her quips about fellow Texan **GEORGE H. W. BUSH**, Reagan's vice president, who was running on the Republican ticket. Still quoted in nearly every article about him to this day is her line that he was "born with a silver foot in his mouth." She also introduced the phrase "Ginger Rogers did everything that Fred Astaire did. She just did it backwards and in high heels."

It was a hell of a speech. It made her a star.

Back home, folks began to push her to run for higher office, and so she ended up running for governor. This was Texas, so the stories about the election are colorful and could take up this whole chapter. Long story short, she ran against a multi-millionaire rancher who made a joke about rape on the campaign trail. She narrowly beat him 49 to 47.

A proud feminist became the governor of Texas. Maybe the winds were shifting a bit.

**MOLLY IVINS**, the daughter of an oil executive, grew up in Houston and once famously wrote, "I dearly love the state of Texas, but I consider that a harmless perversion on my part, and discuss it only with consenting adults." For a decade, she was a columnist

for the *Dallas Times Herald*, though midway through she was transferred to Austin because she'd pissed off too many Dallas locals. When the *Times Herald* was bought and then shuttered by a rival paper in 1991, she was scooped up by the *Fort Worth Star-Telegram* but stayed in Austin. Austin was where she belonged. Around then, the second collection of her columns was published as *Molly Ivins Can't Say That, Can She?* and she became a national star.

Combative, progressive, sharp as a tack, and funny as hell, her columns were cathartic for fellow Progressives who had gone through twelve years under Reagan and then Bush. Feminists, in particular, who'd had a rough decade, and especially White feminists, who'd watched many of their fellow White women retreat into Stepford, were thrilled to see her and Ann Richards out there throwing punches. It felt good.

Pop music was producing some badass work from women, too.

**HIP-HOP** was on its way to becoming the most popular music in the country. It had started as a powerful voice for the urban Black community, a way to communicate humanity and anger to a country full of White people who had chosen to largely ignore them and defund their public services while making money off the drugs that were destroying lives.

White male suburban teenagers became hip-hop's biggest market but were mostly attracted to the anger, not the information. They were particularly fond of some of the more misogynistic parts of it. Record companies picked up on that and began signing and promoting rappers who talked the most about "bitches" and "hos" and bragged the most about "pimping."

Black women also rapped, of course, and had often responded, in verse, to men who put women down. In 1984, **LOLITA SHANTÉ GOODEN** was one of many women who changed their name to Roxanne to respond to a rap trashing a woman of that name.

The **ROXANNE WARS**, however, happened before hip-hop was so culturally dominant. The inescapability of gangsta rap and its growing misogyny required a bigger, more sweeping response. Newark's beautiful, bold, and badass **QUEEN LATIFAH** brought it in 1993 with her song "U.N.I.T.Y." It starts off mellow, a saxophone playing a jazz riff, a little bit of a reggae beat in the background, and then she comes in powerful: "Who you calling a bitch?"

She lays it all out, calling for love, explaining her anger, letting other women know they should expect more. She sets out expectations for the men in her life and a warning for men in general:

> And nothing good gonna come to ya
> til you do right by me
> Brother, you wait and see
> (Who you calling a bitch?)

> WHITE MALE SUBURBAN TEENAGERS BECAME HIP-HOP'S BIGGEST MARKET BUT WERE MOSTLY ATTRACTED TO THE ANGER, NOT THE INFORMATION

In the meantime, White kids in the sub-urbs had been forming bands, as always, and as usual it was mostly boys.

AND YET.

College-age girls had been reading *Back-lash*. Heck, they'd been LIVING *Backlash*. As the feminist movement of the 1970s lost steam, many of the thought leaders had been pulled into academia, where they were teaching women's studies classes to the next generation. Out of this, and the general rage of lots of younger women, came the RIOT GRRRL punk move-ment. These young, mostly White women of the Pacific Northwest decided to take over rock and roll, not just as fans, but as fucking rock stars. The bands were promoted with roughly Xeroxed posters and 'zines referencing the trappings of commercial femininity, and their songs were all about blowing up expectations. In perhaps the most iconic song of the genre, BIKINI KILL'S "Rebel Girl," the Riot Grrrl queen, *KATHLEEN HANNA,* describes not only the girl she loves but, really, all rebel sisters:

OUT OF THIS, AND THE GENERAL RAGE OF A LOT OF YOUNGER WOMEN, CAME THE RIOT GRRRL PUNK MOVEMENT

*When she talks, I hear the revolution
In her hips, there's revolutions
When she walks, the revolution's coming
In her kiss, I taste the revolution!*

The toughest woman of the early nineties, though, by far, was *ANITA HILL,* and her or-deal in 1991 was the source of a lot of the fe-male rage that would come later.

THURGOOD MARSHALL, the pioneering civil rights lawyer who became the FIRST BLACK JUSTICE of the Supreme Court, was a stalwart defender of not only civil rights but also abortion rights and the rights of criminal suspects. In June 1991, he announced he was retiring. He had hoped to hold out until there was a Democrat in the White House, but his body was not willing. It was left to the man Ann Richards loved to mock to ap-point a successor.

The court would be all White again when Marshall stepped down, so there was pressure to find another Black person to nominate. Republican Black people were pretty rare in 1991 after Nix-on's Southern strategy, Reagan's at-tacks on fictional Black welfare queens, and the Willie Horton ad. CLARENCE THOMAS, though, had stuck with the party. He had served as the head of the EQUAL EMPLOY-MENT OPPORTUNITY COMMISSION for eight years during the Reagan administration, and Bush had appointed him to replace Justice ROBERT BORK on the United States Court of Appeals for the District of Columbia Circuit, where he had reliably ruled as a big-C Con-servative. He was a natural choice.

He was known to be particularly con-servative on civil rights issues, having spo-ken out against affirmative action in the past. Though he had never spoken out about abortion, his various political affiliations in-dicated that he would likely rule against

upholding *Roe v. Wade*. These issues, in particular, made him a contentious choice to replace Marshall.

Though he was considered a shoo-in for confirmation, the Democrats on the **SENATE JUDICIARY COMMITTEE** hit him hard on these issues, hoping to portray him as too radi-cally conservative to rule fairly on the bench. Thomas, however, had been far less public in espousing his conservative views than Bork, on whom Democrats had used this technique successfully when he was nominated for a seat. It might fail this time, but at least Democratic protests would be on record.

Then the hearings took an unusual turn. Excerpts from the FBI's report on Thomas for the committee were leaked to **NINA TOTENBERG**, a reporter for NATIONAL PUBLIC RADIO. These showed that Anita Hill alleged Thomas had sexually harassed her when she worked for him first at the DEPARTMENT OF EDUCATION, then at the EEOC, and the allegations were backed up by testimony from two other women. Hill hadn't contacted the FBI; they had contacted her to follow up on rumors. Being a smart lawyer, she had refused to answer questions unless she could make a statement in her own words that would be included in the report.

> BEING A SMART LAWYER, SHE HAD REFUSED TO ANSWER QUESTIONS UNLESS SHE COULD MAKE A STATEMENT IN HER OWN WORDS THAT WOULD BE INCLUDED IN THE REPORT

Totenberg reported what she had been sent, and women began to ask why this wasn't asked about in the hearings. Two days after the story broke, female Representatives made speeches on the House floor demanding the Senate delay the Thomas hearings to address these allegations. In a 2017 interview with the *Washington Post*, **PAT SCHROEDER**, then a representative from Colorado, and **ELEANOR HOLMES NORTON**, who had served as the delegate to the House for the District of Columbia, described what happened next:

Schroeder: And that then inspired us to go over to see the wonderful Senate, because they were having lunch as they always do on Tuesday. So we marched over there to go see them, because we were dumbfounded.

Norton: It was so spontaneous.

Their march outside to the Senate door, along with **LOUISE M. SLAUGHTER** and **NITA M. LOWEY** of New York, **BARBARA BOXER** of California, **PATSY MINK** of Hawaii, and **JOLENE UNSOELD** of Washington, was captured in a video that was shown on every network that night. A dramatic photo was splashed across all the papers the next day. Senator **JOE BIDEN**, the chair of the Judiciary Committee, finally agreed to extend the hearings and call Anita Hill in to testify.

A few months earlier, the hugely popular and controversial film *Thelma & Louise* showed two friends blowing up a trucker's rig after he sexually harassed them on the road. A lot of concerned think pieces responded to this scene in the film asking whether it was fair to destroy a man's livelihood just because he said a few lewd things to some women. The country was poised to explore that question in the real world.

One of the most striking things about the hearing was the visual it presented. There was Anita Hill, a Black woman, sitting alone at a table in her turquoise suit looking up bravely and calmly at the panel of senators, all White men, who seemed to loom over her.

She described what Thomas had done: he'd commented on her breasts, harangued

her to go on a date with him, and made lewd remarks about porn he'd watched. Most memorably, he'd shown her a hair on his Coke can and said it was a pubic hair.

The senators didn't get it. They asked the questions that are always asked of these things: Was he maybe just joking? Did you maybe misinterpret what he said? They accused her of being vindictive, of maybe being a woman scorned. They accused her of trying to destroy a good man's career because of prudishness or sensitivity. The big question was: If it was so terrible, why didn't she quit or report it? Why did she keep working with a man who treated her that way?

Hill had grown up with farmer parents in small-town Oklahoma, the youngest of thirteen children, and it had taken a lot of work to go from there to a degree from YALE LAW SCHOOL. Her success had made her family and community proud and hopeful. Throwing away job opportunities was not something she felt she could do, so when Thomas asked her to serve as his assistant in his new position as head of the EEOC, she took the job, despite the occasional harassment.

The conservative Christian faith she'd been raised in made her unsure about challenging a man in authority and concerned that perhaps she was somehow behaving in a way that was bringing on this harassment. Her conservative faith was enough of an influence in her life that she taught for three years at the EVANGELICAL CHRISTIAN O. W. COBURN SCHOOL OF LAW at ORAL ROBERTS UNIVERSITY after she left the EEOC.

*THEY ACCUSED HER OF TRYING TO DESTROY A GOOD MAN'S CAREER BECAUSE OF PRUDISHNESS OR SENSITIVITY. THE BIG QUESTION WAS: IF IT WAS SO TERRIBLE, WHY DIDN'T SHE QUIT OR REPORT IT?*

Most important, though, was that, as an EEOC lawyer who worked on workplace discrimination cases, she knew what happened to women who complained. Even those who won suits were labeled as troublemakers and then found it hard to find employment after. Not to mention, the federal agency that was supposed to enforce laws against gender discrimination was the agency in which she worked, and it was headed up by the man who was harassing her. Of course she didn't feel like she could complain.

When Thomas was called to testify, he called the proceedings a "high-tech lynching," evoking the Black men throughout history who had been killed over false accusations of sexual misconduct. Hill knew this history, too, and she knew how angry a lot of Black people were that she was willingly hurting a successful Black man.

Though he invoked historical racism to defend himself, Thomas did not refer to the historical treatment of Black women as sexually available and for the taking, and in the FBI report, the women interviewed about Anita Hill's treatment noted that he was known for treating only Black women this way.

Plenty of Black women saw themselves in Hill and understood how important what she was doing was. In a powerful statement, sixteen hundred of those Black women contributed money to take out an ad in the *New York Times* showing their support, with all their names listed.

Still, the hearings came just a few months after the whole world saw video of multiple LA POLICE OFFICERS mercilessly beating taxi driver RODNEY KING after he'd led them on a high-speed chase through the city. It was brutal and unsettling to see the officers knocking him down with nightsticks every time he tried to stand—a scene that was all too familiar to Black citizens who had dealt with authorities. Although most Black leaders had withheld their support for Thomas's nomination on the basis of his politics, they still felt discomfort watching a Black man be knocked around on TV again, even if it was only figuratively.

In the end, Thomas was confirmed anyway, and would become the most conservative on the court. Hill became the perennial subject of published right-wing rants and was famously dubbed by one reporter "a little bit nutty and a little bit slutty." She became a bit of an obsession with conservatives, and her vilification followed her. In 2010, almost twenty years after the hearings, Thomas's wife, *VIRGINIA,* a White woman who had long been active in right-wing causes, left a voicemail for Hill at

> IN THE END, THOMAS WAS CONFIRMED ANYWAY, AND WOULD BECOME THE MOST CONSERVATIVE ON THE COURT

Brandeis University, where she had been a professor for several years:

> Good morning, Anita Hill, it's Ginni Thomas. I just wanted to reach across the airwaves and the years and ask you to consider something. I would love you to consider an apology sometime and some full explanation of why you did what you did with my husband. So give it some thought. And certainly pray about this and hope that one day you will help us understand why you did what you did. OK, have a good day.

For some, Anita Hill will always be the woman who wanted to destroy a successful man.

These issues echoed a few years later, in 1995, when football star O. J. SIMPSON, a successful Black man who had crossed over into rich White society, was accused of killing his ex-wife, *NICOLE BROWN SIMPSON,* who was White. All of the forensic evidence was against him, as was the time line, and she had called the police on him several times during their marriage for abuse. The police did nothing about the domestic abuse once they saw the accused was O. J. Simpson, the guy who'd run a bunch of yards once during a football game, but the records of the calls existed, and she had saved photographs of herself with the black eyes he'd given in case she ever needed them as evidence.

Still, the trial took place in LA with a majority Black jury. The LAPD had a horrific history with the Black community, far beyond the RODNEY KING INCIDENT, and these jurors had a difficult time believing anything law enforcement claimed.

The trial was televised, and bizarrely went on for over a year; the nation was obsessed with it. The jury was sequestered the whole time and began to look more and more like prisoners as the months wore on. The entire country went silent in the moments leading up to the verdict. In the end, O. J. was acquitted. Many in the Black community celebrated, and most of the White community were shocked that people in the Black community were celebrating. The moment illuminated a very clear divide in the country.

But back to 1991.

Thousands of women—perhaps millions—watched the Clarence Thomas hearings and saw themselves in Anita Hill. They had also suffered through sexual harassment to hold on to a career, or more often to hold on to a job that kept their families fed. The cluelessness of the senators questioning Hill, particularly the ones who were considered "Progressive," was infuriating. It was not lost on them that all on the committee were men.

When the women representatives marched over to the Senate, it had been striking to see how few of them there were, and even more striking that there was only one female senator to receive them.

The 1992 election became known as the YEAR OF THE WOMAN. Twenty-four women were elected to the House, the largest number elected in a single election. The number of female senators tripled to three. The election also made George H. W. a one-termer, bringing in a young governor from Arkansas and a rather different First Lady.

HILLARY RODHAM was raised near Chicago, where the Democratic Party was notoriously corrupt. Her father was a Republican, as was her favorite high school history teacher. Between them they made sure she knew about the Illinois "voters" listed as living in empty lots in the election in which Kennedy had narrowly won the state over Nixon. When she was sixteen, her dad and the history teacher were big fans of BARRY GOLDWATER, the advance guard of the small-government, libertarian, every-man-for-himself wing of the Republican Party and their nominee for president in the 1964 election. Goldwater had supported civil rights reforms in the past but believed the CIVIL RIGHTS ACT of 1964 was an overreach, and he ran hard on that platform against LYNDON JOHNSON, who had ushered the bill into law.

Trusting in the wisdom of the influential men in her life, Hillary helped her father do Goldwater campaign work for a bit, handing out flyers, stuffing envelopes, that sort of

**THE 1992 ELECTION BECAME KNOWN AS THE YEAR OF THE WOMAN**

### MANY VOTERS IN ARKANSAS WERE UNCOMFORTABLE WITH A FIRST LADY WHO'D KEPT HER OWN LAST NAME AND DIDN'T WEAR MAKEUP OR SET HER HAIR

thing. Then the history teacher took her class to see the REV. MARTIN LUTHER KING JR. speak, and it changed everything. King explained things she hadn't heard about in her White suburban enclave.

Being who she was, she did a lot of reading. After some time looking into history and current events, she became a passionate Progressive. As an undergrad at WELLESLEY COLLEGE, she became a bit of a superstar, eventually becoming the first student ever to give a keynote speech at graduation. She was featured in *Life* magazine wearing amazing striped pants and enormous glasses. Then, when she sat for the admissions test for HARVARD LAW SCHOOL with one other woman, whenever the proctor was out of the room the men would yell at them for trying to take "their" spots at the school. After all that, she was rejected because the law school had already admitted its quota of women. She attended YALE LAW SCHOOL instead—one of the first women to do so—and there she met BILL CLINTON, a charismatic man who was almost smart enough to keep up with her. They fell madly in love, and he kept proposing, but he wanted to go home to Arkansas to work

on improving conditions there, and she had dreams of working in DC.

Courted by big-shot law firms, she chose instead to work with one of her mentors, **MARIAN WRIGHT EDELMAN** at the CHILDREN'S DEFENSE FUND. One of her first assignments was working undercover to expose segregationist practices in Alabama. She later worked on the impeachment inquiry staff of the House Judiciary Committee during the Watergate scandal, and attracted more and more mentors who hoped to help her become a senator eventually, possibly even president.

Then came a sudden turning point: she failed the DC bar exam. It was known to be tough, but she was mortified and too embarrassed to tell anyone. She felt like she had let down all these people who believed in her. She'd passed the Arkansas bar exam during a visit with Bill, and they were already living together, so she finally agreed to marry him and move to Little Rock.

Many of her friends thought she was throwing her career away, but she did amazing work there setting up legal clinics and doing pro bono work while establishing a successful law career and authoring papers for journals. Meanwhile, Bill became governor. He then lost his reelection bid in part because many voters in Arkansas were uncomfortable with a First Lady who'd kept her own last name and didn't wear makeup or set her hair. Hillary set her hair, changed her name to Hillary Rodham Clinton, and Bill was elected governor again.

All of this to say that Hillary Rodham Clinton was well established on her own with an extremely successful career when Bill was elected president of the United States. This became an issue during the presidential campaign, with the press asking over and over why she hadn't dedicated her time as first lady in Arkansas to supporting her husband instead of working in a field that opened up potentials for conflicts of interest. One day she snapped and said,

> I suppose I could have stayed home and baked cookies and had teas, but what I decided to do was to fulfill my profession, which I entered before my husband was in public life.

This, of course, offended the hell out of the homemakers of America, and she ended up having to publish a cookie recipe in *Family Circle*, as did **BARBARA BUSH**, wife of **GEORGE H. W.**, Bill Clinton's opponent—another powerful woman who had also likely not done a lot of cookie baking in her life.

That Bill had cheated on her during the course of the marriage was an even thornier issue, and Hillary eventually ended up sitting next to him on television discussing it, saying that they had worked through it and moved on. The problem was he seemed to have cheated on her a lot, and some wondered about voting for a rumored womanizer in the wake of the Clarence Thomas hearings. Hillary's reassurances helped, but his fidelity would remain an issue.

Bill, proud as hell of his accomplished wife, assumed everyone else would be, too, and talked her up as his political partner. He even put her in charge of health-care reform. Much of the country was not comfortable with this, and not sure what to make of her. There had been politically active First Ladies before of course, like **ELEANOR ROOSEVELT** and **BETTY FORD**, though they had never come from the kind of serious career background that Hillary did. That hadn't really been an option before. There was lots of talk about Hillary's hair, which never seemed right to people.

After her health-care reform plan failed amid **LADY MACBETH** comparisons lobbed her way, she took on a more traditional First Lady role. She still had some breakout radical moments, though. In 1995, she was the keynote speaker at the **FOURTH WORLD CONFERENCE ON WOMEN** in Beijing. Her speech was unabashedly feminist and contained a traditional feminist phrase that has now become part of her legend: "Human rights are women's rights and women's rights are human rights."

The speech was quietly received back home, but internationally it made her a superstar among women. To many, it felt

*IT FELT REVOLUTIONARY FOR THE FIRST LADY OF THE MOST POWERFUL NATION ON EARTH TO STAND UP SO STRONGLY FOR WOMEN'S RIGHTS*

revolutionary for the First Lady of the most powerful nation on earth to stand up so strongly for women's rights. She began traveling more, visiting with women's groups all over the world, supporting them how she could. Sometimes this was in partnership with her friend, **MADELEINE ALBRIGHT,** policy adviser and ambassador to the United Nations whom Bill would appoint as the first female secretary of state in 1997.

Back in DC, the 1994 midterm elections had flipped the House, and some pretty radical Republicans were in charge. They immediately began investigating the hell out of the Clintons, positive they'd find some major corruption somewhere to justify their intense dislike of the couple. They finally came across a minor land deal in Arkansas that the Clintons lost money on, and it looked promising, so opponents started in on that, appointing **KENNETH STARR** as independent investigator. His investigation quickly went way beyond the land deal and explored every possible nook and cranny. At last, through a convoluted and depressing series of events, he stumbled across an allegation that Bill Clinton had received blow jobs from an intern in the Oval Office. It was in no way connected to the land deal, but it would do.

The intern, **MONICA LEWINSKY,** had confided in the wrong person and her life was about to become hell on earth. She was threatened by Starr and his investigators, she was viciously slut-shamed in the media for years, and she felt abandoned by Bill, who she had naively believed was a friend she could count on. In later years, she spoke out about coming to terms with the sexual harassment aspects of what had happened and the journey she had to take to see how inappropriate the relationship was, things she hadn't been able to admit to herself as a young woman.

Bill claimed in front of a grand jury that he hadn't had sex with Monica Lewinsky, but a blue dress of hers had his semen on it (say "the blue dress" to anyone who lived through that time and they'll know what you're talking about). Clinton was impeached on charges of lying to the grand jury. Ultimately, he was acquitted and then actually had some of his highest approval ratings as president afterward because much of the general public thought the GOP had gone a bit overboard.

Hillary, meanwhile, was utterly humiliated. Bill had lied to her about it, too, and she had stood up for him. It was devastating to realize she had been betrayed. This was the first major opportunity for the world to see what Hillary Rodham Clinton did when she was knocked down. She got sad, she got angry, she retreated for a bit. She prayed and mulled and considered. Then she rallied, did the work she needed to do to make peace, and rose again.

**THEN SHE RALLIED, DID THE WORK SHE NEEDED TO DO TO MAKE PEACE, AND ROSE AGAIN**

At the end of Bill's term, his VP, **AL GORE,** became the Democratic nominee for president. It was tricky for Gore to run so soon after his boss had been in a major scandal, and he faced a third-party candidate who claimed both parties were the same. Still, he narrowly won the popular vote against **GEORGE W. BUSH,** son of George H. W. Bush, famously dubbed "Shrub" by Ann Richards.

Unfortunately, the popular vote is meaningless in our presidential elections, and the winner of the Electoral College was still up in the air. Florida, governed by **JEB BUSH,** brother to George W. Bush, had some ballot issues: some ballot holes were not fully punched, leaving hanging chads. Also, suddenly a bunch of roads were closed for construction on election day in Black neighborhoods, but hanging chads took up most of the spotlight. Gore called for a recount, and the question of who would be president hung—like a chad—for weeks. The Republicans brought a suit in front of the Supreme Court asking that the recount be suspended. In a 5–4 ruling, the court brought it to a halt. Clarence Thomas, naturally, was among the majority vote.

Despite losing the popular vote, George W. Bush became president, thanks to the ruling of five Supreme Court judges. Four years later, **MARK ZUCKERBERG** would launch Facebook, which quickly became the most depressing reason that someone won an election, but this was the worst up until then.

*HER STRENGTH WAS TESTED A YEAR LATER WHEN TERRORISTS ATTACKED AMERICA'S FINANCIAL CENTER, LOCATED IN HER HOME STATE, KILLING OVER THREE THOUSAND PEOPLE AND LEAVING THE WALL STREET AREA IN RUINS*

W, as he was known, would go on to invade a country for made-up reasons and preside over the worst financial meltdown since the **GREAT DEPRESSION.**

Hillary had, in the meantime, rallied after her humiliation, run for senator in **NEW YORK**—and won! Now she was **SENATOR CLINTON.**

Her strength was tested a year later when terrorists attacked America's financial center, located in her home state, killing over three thousand people and leaving the Wall Street area in ruins. Her efforts to help rebuild earned her the respect and support of people who worked on Wall Street, which would come to haunt her later.

She was reelected six years later but had her eyes set on a higher office: the presidency.

If this book had been written before 2016, here it extensively would describe the sexism she faced as she ran in the Democratic primaries against charismatic upstart **BARACK OBAMA.** A paragraph would be devoted to his calling her "likable enough," and the nutcrackers made in her image would certainly be discussed.

It definitely must be mentioned that after Hillary lost the Democratic primary, **JOHN McCAIN,** the Republican candidate, picked **SARAH PALIN** as his running mate in the hopes of appealing to women who were disappointed with Hillary's loss. Palin experienced sexist treatment herself and was

unfairly labeled as dumb and unhinged for espousing ideas that men in her party had been openly expressing for years.

The whole election seemed kind of over the top at the time, but not so much after 2016. Nothing seems over the top after 2016.

In November 2008, Barack Obama became the FIRST BLACK PRESIDENT in American history, and it was amazing. Black people, in particular, knew he was facing a difficult road and that this didn't necessarily indicate the profound shift in society that White people thought it did.

All that aside, when he and his spectacular wife, MICHELLE, danced on INAUGURATION NIGHT to BEYONCÉ singing "At Last," it was hard for most people not to feel what the election's ubiquitous silkscreened posters of his face had suggested: hope.

## CHAPTER 12

# THIS IS WHAT A FEMINIST LOOKS LIKE

## 2009 TO NOW

**THE 2008 DEMOCRATIC PRIMARY** had been a marathon, with delegate tallies so close that no one conceded until the fiftieth primary was in the can. The scrappy young senator from Illinois, Barack Obama, had received 127 more pledged delegates than the scrappy older senator from New York, Hillary Clinton, so he became the presumptive nominee. They both were historic candidates, and it was powerful and sometimes painful to watch them battle each other. Hillary demonstrated that a woman could go the distance in a bruising national campaign and then powerfully acknowledged the astounding historical importance of Senator Obama's accomplishment in her concession speech.

Still, there were some hurt feelings left over after all those months, so two days after Obama officially became the nominee, Senator **DIANNE FEINSTEIN** of California had Hillary and Barack over to her house to chat. She left them alone in her living room with some water, and an hour later they came out laughing, having smoothed over all the ruffled feathers. Hillary, and Bill, went out on the road a couple of days later to campaign for Obama all over the country. At the convention in July, Bill gave his brilliant "Arithmetic" speech in support of Obama and Democrats in general, and Hillary gave her now legendary **"GLASS CEILING"** speech, with the lines,

> Although we weren't able to shatter that highest, hardest glass ceiling this time, thanks to you, it's got about 18 million cracks in it, and the light is shining through like never before, filling us all with the hope and the sure knowledge that the path will be a little easier next time.

As it turned out, the path wasn't easier the next time, but we'll get to that.

Though some wanted Obama to pick Hillary as his running mate, neither candidate wanted that, and it would have put her in the position of helpmeet, even if it would have made her the backup president. Who would want the first female president to get into office because the first Black president had died? Obama instead chose Senator **JOE BIDEN**, an older White man who might reassure those uncomfortable with the idea of a Black president but who also knew how to respectfully defer to his boss. Though some old enough to remember still bristled over his handling of **ANITA HILL'S** allegations against Clarence Thomas, he had since been a strong advocate for women in the Senate, including sponsoring the **VIOLENCE AGAINST WOMEN ACT**, so he was not worrisome. Plus, he was charming as hell. They made a fun team, like in a buddy cop movie.

The buddies won the general election. Not handily, but solidly. After what had been a tough eight years for Progressives, it felt like maybe America could still do amazing things. Young people had turned out in slightly higher numbers for a candidate who seemed cool and who inspired passion.

**THEY MADE A FUN TEAM, LIKE IN A BUDDY COP MOVIE**

*" . . . AND THE LIGHT IS SHINING THROUGH LIKE NEVER BEFORE, FILLING US ALL WITH THE HOPE AND THE SURE KNOWLEDGE THAT THE PATH WILL BE A LITTLE EASIER NEXT TIME"*

He made Hillary Clinton his secretary of state, and she immediately began structuring the State Department to take more seriously the women's issues she'd seen while traveling the world.

As a further nod to women's rights, he pushed through and signed the LILLY LEDBETTER ACT, which removed the statute of limitations on women making lost-wages claims over past pay inequality.

Then he got to work on the rest of what he wanted to do and what his coalition had wanted him to do, hoping they would have his back.

The first test was in Massachusetts, where "the shot heard round the world" was fired, the opening round in the fight for democracy in this country, where they'd thrown tea off a ship to spite a monarch, and where they had torn his symbols from the rooftops of buildings.

A state considered extremely liberal, Massachusetts had gone nearly 62 percent for President Obama and his policy positions. It went without saying that the state would want to do what it could to help him make those policies a reality. Right?

In 2009, Senator TED KENNEDY died. He'd been the senator from Massachusetts for decades. He was the LIBERAL LION of the Senate, the man Republicans loved to hate. One of the issues he'd been working on for his entire time serving was health-care reform. He was thrilled when Obama was elected with a Democratic House and Senate to work with. It was a second chance to try what he'd tried with Hillary Clinton in 1993.

When he died, the health-care bill had already passed in the Senate, and after NANCY PELOSI, the first female Speaker of the House managed to wrangle her Democratic cats, their version of the bill passed in the House. All that was left was to reconcile the two bills and send them through again. It was a huge document, so it took time to do it, but they had enough Democratic votes in the Senate—60—to ensure that it could go through again without debate. Then Kennedy died. Still, it was Massachusetts!

MARTHA COAKLEY, the state's attorney general, was the Democratic nominee for the Senate seat Kennedy left vacant. SCOTT BROWN, who served in the state legislature, was the Republican nominee. Coakley didn't shake hands enough and mistakenly said that conservative World Series hero CURT SCHILLING was a member of the Yankees. Brown started wearing a barn coat and bought a truck. He also ran hard against the health-care bill. Brown won.

Voter turnout for the presidential election had been 67 percent. For the special election that would decide the fate of Obama's signature policy proposal, it was 54 percent. This was in part a result of too many people assuming the Democrat would win in Massachusetts and not focusing on voter turnout. It was also a sign of how passionate the opposition to Obama would become.

Obama, Pelosi, and Senate majority leader HARRY REID did some hustling to avoid

further debate on the bill and got it through, but it made them look sneaky.

There was an illusion of an Obama coalition who were all committed to doing the work to make his policy proposals reality, but once he was elected people drifted back into their own lives. It was the perfect illustration of what **ELLA BAKER** had warned against: people investing too much hope in one leader.

When Obama said **"YES, WE CAN,"** he meant "Yes, we can all work together to make the changes we think this country needs." Many of his supporters seemed to hear "Yes, we can get me elected so I can fix everything myself."

His election also made a lot of White people think that racism was over, that they didn't have to worry too much about it anymore. It was the same kind of complacency that **PHYLLIS SCHLAFLY** had exploited when she helped defeat the **ERA,** and it was a playbook still followed by her and her "traditional values" compatriots.

Yes, Phyllis was still at it, and she'd been training younger women and men to follow in her footsteps. Supporters of the **CHRISTIAN RIGHT** had been running for low-level political offices for years, making use of the poor turnout for state elections. They'd gotten onto school boards and banned the teaching of evolution, they'd rolled back affirmative action initiatives, they'd eroded reproductive

*WHEN OBAMA SAID "YES, WE CAN," HE MEANT "YES, WE CAN ALL WORK TOGETHER TO MAKE THE CHANGES WE THINK THIS COUNTRY NEEDS"*

rights one state level bill at a time, they'd given single mothers work requirements to collect food stamps even while talking up the importance of mothers' staying home to raise their children, and so on. They'd also gerrymandered the heck out of their states, consolidating power.

It paid off in the 2010 midterms.

Aided by the **TEA PARTY "MOVEMENT,"** which was supposed to be a reaction to the economic collapse but seemed to be made up of a lot of White people who didn't trust President Obama just "for some reason," the Republicans took the House and Senate in the 2010 midterms. This closed the window the Democrats had to get more of their agenda passed, a reality that was driven home when the new Senate majority leader **MITCH McCONNELL** announced that his primary goal in his new position was to block absolutely anything President Obama tried to accomplish.

Meanwhile, for a reality show host had publicly claimed that President Obama had been born in a foreign country, despite evidence from Hawaii that Obama had been born there. Lots of people weirdly believed this wingnut conspiracy theory, but this guy was the ringleader.

In 2011, at the **WHITE HOUSE CORRESPONDENTS DINNER,** with the reality show host sitting in the audience, President Obama mocked him. It was hilarious and

sharp, and it really pissed the guy off. At the same time, on Obama's orders, Seal Team 6 had begun the mission to capture **OSAMA BIN LADEN,** the man who had planned and coordinated the September 11 attacks. The day after the dinner, President Obama interrupted the reality show host's program to tell the nation that Osama bin Laden had been captured and killed. This would all become a problem later.

Women with a feminist bent had already been stirred up by Hillary's loss, and more specifically by the treatment she'd received by some of the Progressive men they'd considered allies. Now even more women were concerned as the Republicans started introducing radical antiabortion and birth control bills in the House and Senate, along with the state bills that were proposed and passed.

The Republican initiatives were dubbed the WAR ON WOMEN, and women started fighting back. Politics had already migrated to SOCIAL MEDIA, and the invention of smart phones a few years earlier meant people were connecting to their social media accounts more often. Soon, they were always connected, and there was great power in that. The flash mob concept was used for flash protests, such as OCCUPY WALL STREET, which drew attention to income inequality when Occupiers camped out in financial centers around the country. The Occupy movement didn't translate that attention into votes, as demonstrated in the 2010 midterms, but others hoped they could with the same techniques.

Feminists took to Twitter, made connections, and started up Facebook pages to set up communities.

Women also started admitting to being feminists, which in itself was amazing. It began with "This Is What a Feminist Looks Like" T-shirts just a few years earlier, but it was most thrilling when BEYONCÉ performed in front of the word in giant glowing letters.

President Obama appointed two more women to the Supreme Court, ELENA KAGAN and SONIA SOTOMAYOR, giving RUTH BADER GINSBURG, the Notorious RBG, a little company.

Women's efforts helped Obama beat GOP nominee MITT ROMNEY in the 2012 election. Romney was fond of praising his wife's choice to stay home with their children but had made poor women work outside the home for their benefits when he had been governor of Massachusetts. He also was the governor who helped create the Massachusetts health-care system yet had run in opposition to the similar national health-care bill. But, whatever.

HASHTAG ACTIVISM wasn't enough to counter all that gerrymandering, and the Republicans held the House, though they did lose their supermajority in the Senate. Now they just had a boring vanilla majority, which was a bit better.

Hillary stepped down as secretary of state to relax for a bit after flying all over the world. The Republicans missed her, and hauled her back to DC a bunch of times to testify about a terrorist attack in LIBYA they blamed her for. They investigated and investigated and investigated and found nothing and investigated some more. Once they had her testify for eleven hours. They still found nothing to pin on her.

ONCE THEY HAD HER TESTIFY FOR ELEVEN HOURS, THEY STILL FOUND NOTHING TO PIN ON HER.

When the Republicans weren't doing that, they were trying to overturn Obamacare, as they called the health-care bill, properly known as the **AFFORDABLE CARE ACT.** They also spent some time trying to defund **PLANNED PARENTHOOD.**

The year of the midterms, a fourteen-year-old unarmed Black boy was shot while walking home from the store by a self-appointed neighborhood vigilante who didn't think the boy belonged there. It was raining, so Martin was wearing a hoodie. Fox News, the propaganda wing of the Republican Party, went into overdrive to convince its viewers that the hoodie meant the boy was a thug who had it coming, and its viewers were convinced.

When President Obama spoke of the event as a tragedy and said that **TRAYVON MARTIN** looked like he could be his son, a whole lot of White people got mad. They thought there was an unspoken deal that they would let him be president, but he was never, ever supposed to say that people might be racist.

Three women, **ALICIA GARZA, PATRISSE CULLORS,** and **OPAL TOMETI,** founded **BLACK LIVES MATTER** in 2013 as a response to the acquittal of the man who had murdered Martin. Experienced community organizers, the women built Black Lives Matter into a powerful and focused organizing project able to swiftly and effectively help with community responses to killings of unarmed Black people

around the country. When **MICHAEL BROWN,** a young, unarmed Black man in **FERGUSON, MISSOURI,** was shot at twelve times by police, with six bullets hitting him and killing him, Black Lives Matter helped organize the massive protests that held the country's attention for weeks.

**SMART PHONES** took on a new role as witnesses to police brutality. We saw video of *SANDRA BLAND* thrown to the ground by a White police officer after he pulled her over, claiming she hadn't signaled at a turn. She was arrested and the next day found dead in her jail cell. We saw a White police officer pointing his gun at Black teenagers at a pool party and then throwing one of the girls, clad only in her swimsuit, to the ground and kneeling on her back. We saw **ERIC GARNER** strangled to death for selling loose cigarettes. It just kept going.

Still, many White people saw Black Lives Matter as a rabble-rousing group, if not terroristic in nature. In the Fox News universe, the victims were all described as thugs deserving of what they got. When President Obama had expressed sympathy for Trayvon Martin and his family, it made many White people uncomfortable. When he later voiced support for Black Lives Matter, he lost all those White people who had voted for him conditionally. He'd reminded them that he was Black.

> THEY HAD MADE AN UNSPOKEN DEAL THAT THEY WOULD LET HIM BE PRESIDENT, BUT HE WAS NEVER, EVER SUPPOSED TO SAY THAT PEOPLE MIGHT BE RACIST

**SAME-SEX MARRIAGE** was legalized by the Supreme Court after a long-fought battle, meaning states could no longer forbid it. The White House was lit in rainbow colors that night. The "traditional values" ilk were mad. Schlafly said in a speech that at least they'd defeated the ERA and kept it from happening sooner.

The 2014 midterms saw no real change.

Beyoncé's political statements increased, and she started addressing and exploring her Blackness in complex, powerful songs and long-form videos that were thrilling to the Black community, and a little scary to some of the White people who had really liked dancing to "Single Ladies."

**SHERYL SANDBERG,** a Facebook executive, wrote a book urging women to "lean in," suggesting that maybe women just weren't trying hard enough and that's why they weren't doing as well as men were financially. She admitted later that her experiences as a rich White woman with a helpful husband and lots of staff might have clouded her conclusions a bit.

Then came the **2016 ELECTIONS.** Hillary was running again. She had an opponent in the primary, an older White guy who had been an activist in college, had moved to Vermont, and then years later had become a senator. He talked a lot about breaking up the big banks and seemed to address income equality directly. He became very popular among young people who considered Hillary too much of The Establishment. They'd also heard that she'd been a *GOLDWATER GIRL.*

## SHE PREPARED TO FACE HER GENERAL ELECTION OPPONENT: THE REALITY SHOW HOST, WHO WAS STILL REALLY MAD

Women who said on social media that they supported Hillary over her primary opponent experienced incredibly negative blowback, sometimes from people they knew, sometimes from total strangers who appeared out of nowhere. When they complained, Progressive men told them they were being too sensitive.

Women who had experienced or observed **#GAMERGATE**—in which women who developed or reviewed video games were threatened with rape and death and had their addresses exposed online—noticed that the attacks on women who supported Hillary seemed to be coming from the same places. When they shared their observations, Progressive men said they were self-absorbed.

Women who supported Hillary started secret groups on Facebook to share their enthusiasm without getting yelled at and to complain about her primary opponent and his aggressive supporters.

Hillary won the primary by millions of votes and hundreds of pledged delegates.

She prepared to face her general election opponent: the reality show host, who was still really mad.

He was still pushing his theory that Obama was a foreigner. When he launched his campaign, he also stated that most Mexican immigrants were rapists. Plus, he had been heard on tape bragging about grabbing women he didn't know by the pussy. He came off as a little too comfortable with the support he was getting on Twitter from avowed White supremacists. He seemed to be awfully fond of **VLADIMIR PUTIN,** the authoritarian leader of Russia who liked to have his critics killed.

**THIS MADE THE PEOPLE WHO HATED HILLARY *EVEN ANGRIER***

When Hillary was secretary of state, concerned about the security of government network servers, she'd installed a private server with higher security at her home and used it for work. The FBI investigated this at length at the request of the Republicans. The FBI concluded that she had not used best practices a couple of times but that she had done nothing that rose to the level of a crime.

This made the people who hated Hillary even angrier. At campaign rallies, the reality show host would call for Hillary to be locked up and lead people in chanting "Lock her up!

*UNSAVORY STORIES KEPT COMING OUT ABOUT THE REALITY SHOW HOST*

Lock her up!" If they beat up a protester in the audience, he'd cheer them on.

Unsavory stories kept coming out about the reality show host: his "university" had been a scam that bilked thousands of people out of money, he'd paid off numerous women to keep them quiet about sexual affairs, he was fond of walking unannounced into the dressing room at the teen beauty pageant he sponsored, he owed thousands of dollars to people who had done work for him, American banks had stopped lending to him because he never paid them back, he owed thousands overseas, and so on.

In the interest of balanced reporting, when these issues were reported on TV the media were careful to mention that Hillary DID use that private server.

Just before the Democratic National Convention, **WIKILEAKS,** a secretive organization that publishes content stolen by hackers, released emails that had been lifted off the servers of the Democratic National Committee. These messages showed that some people inside the DNC had not liked Hillary's primary opponent and didn't want him to win, which infuriated the opponent's supporters. According to all the intelligence agencies, these emails were stolen by Russian operatives. That fact kind of got buried in all the talk about the content of the emails.

The reality show host called Hillary a **NASTY WOMAN** during the first debate. He stalked her onstage during the town hall debate. He talked about how much better our relationship with Russia would be if he was president because Putin liked him and hated Hillary.

Hillary, a former secretary of state who was still in regular contact with power players around the world, pointed out that maybe Putin liked the reality show host better because the reality show host was Putin's puppet.

"No puppet! No puppet! You're the puppet!" was the reality show host's reply.

Days before the presidential election, the head of the FBI sent an open letter to Congress saying that the FBI might need to investigate more of Hillary's emails.

The next day, he said never mind. It was nothing.

The reality show host won the election.

Technically.

Hillary got millions more votes overall, but the reality show host won in the **ELECTORAL COLLEGE,** the system set up by the Founders to reassure the rural slave states that their votes would count as much as the votes of the Free States.

Women overall had voted by large margins for Hillary, but 53 percent of White women had voted for the reality show host. They were sticking with **"TRADITIONAL VALUES."**

But some other White women thought maybe there should be a protest the day after the inauguration, in DC, and another White woman suggested maybe they all knit spe-cial hats in a pattern called the **PUSSY HAT.** The idea gained momentum and seemed to be getting really huge. Yarn stores all over the country were selling out of yarn in the pink used to make the hats. It became a problem that only White women were running the protest, so an official committee was formed that included and was led by women of color.

The day before the march, buses, trains, and airplanes were filled with women wearing silly pink knit hats, the little ears sticking up so you could see them over the seatbacks, headed to the nation's capital. In DC, the women with the pink hats filled the subway stations, the view interrupted only occasionally by formally dressed people on the way to an inaugural ball.

On the morning of the march, everyone watched amazed as every street became a sea of pink hats and waving protests signs. There were LOTS of White women, yes, many there to be an answer to the 53 percent. There was also a LARGE number of women of color. Truly.

On stage at the rally, **JANELLE MONÁE** had protesters say out loud the names of the Black women killed by police brutality. The MOTHERS OF THE MOVEMENT, a group started by Trayvon Martin's mother, which had campaigned hard for Hillary, spoke about the children they had lost. It was powerful.

MICHAEL MOORE talked for way too long and got cut off by **ASHLEY JUDD.** That was fun.

Then the women marched, taking over all the streets for hours.

Not just in DC but all around the country.

There was some hope. Maybe we could fight this.

**THEN THE WOMEN MARCHED, TAKING OVER ALL THE STREETS FOR HOURS. NOT JUST IN DC BUT ALL AROUND THE COUNTRY.**

The administration was as bad as expected. Worse, even. Pushing authoritarianism in the ways that **MASHA GESSEN** and **SARAH KENDZIOR** had warned us it would.

Women, though, kept organizing. Kept fighting. Kept signing up to run for office, calling representatives. Being nasty.

Then, in March of 2017, in a huge shock, NEVADA suddenly ratified the ERA. Just like that. No state had ratified since 1975. In May of 2018, ILLINOIS, where so many thought the ERA had gasped its last breath, ratified, too, leaving the amendment just one state away from its required thirty-eight approvals. One state!

In England, PRINCE HARRY, descended from King George III through multiple lines, son of the late and lovely **PRINCESS DIANA,** married the marvelous **MEGHAN MARKLE,** African American Californian, actor, and crusader for women's rights since childhood. Viewers across the pond, up early with tea

*WOMEN, THOUGH, KEPT ORGANIZING. KEPT FIGHTING. KEPT SIGNING UP TO RUN FOR OFFICE, CALLING REPRESENTATIVES. BEING NASTY.*

and gin, tuned in expecting the usual traditional royal affair and instead were treated to a moving mixture of RALPH VAUGHAN WILLIAMS and BEN E. KING. The Presiding Bishop and Primate of the Episcopal Church in the United States, the MOST REVEREND MICHAEL CURRY, the first African American to hold that position, was chosen to give the main address. He thundered.

The House of Windsor, used to polite and prompt worship, instead saw their five-century-old chapel filled with traditional African American preaching, which easily expanded into every crevice, lifting any bit of dust that might be lingering in the rafters. He spoke of love and family, but he also spoke of history, of "slaves in America's antebellum South" finding strength in spiritual love, the same spiritual love he called on the gathered royals to embrace. Left unsaid, but visible beneath the surface of those words, was that those royals, including the groom, were descended from Charles II, who in 1672 incorporated the Royal African Com-

> "IMAGINE," HE SAID, "THIS TIRED OLD WORLD WHEN LOVE IS THE WAY."

> THE HOUSE OF WINDSOR, USED TO POLITE AND PROMPT WORSHIP, INSTEAD SAW THEIR FIVE-CENTURY-OLD CHAPEL FILLED WITH TRADITIONAL AFRICAN AMERICAN PREACHING

pany to oversee the trade and transport of slaves between West Africa and the American colonies. The immense wealth this venture generated, the bishop was reminding the assembled, was funding this pomp and circumstance. The bride was descended from the people who had paid for it with their blood, toil, tears, and sweat. The bishop, though, brought us back to love. "Imagine," he said, "this tired old world when love is the way."

Nodding in the quire of the chapel, familiar with all that the bishop was saying, was OPRAH WINFREY, every woman.

Later, PRINCE CHARLES, father of the groom, heir to the British throne, in a pale gray tuxedo with a hot pink boutonnière, walked across the aisle and extended his arm to DORIA RAGLAND, the bride's mother, yoga instructor and political activist, all in

> HE SPOKE OF LOVE AND FAMILY, BUT HE ALSO SPOKE OF HISTORY

> **"THE WAY TO RIGHT WRONGS IS TO TURN THE LIGHT OF TRUTH UPON THEM"**

mint green, her hat perched rakishly on her locs.

There in Saint George's Chapel, built before the Church of England split from the Catholic Church so King Henry XIII could get a divorce, and a seat of canon law three centuries before the Declaration of Independence was signed, the White male heir to the British throne walked arm and arm with a Black American woman, who as a single mother had raised her daughter to be a feminist.

They smiled at each other and spoke warmly as they walked as equals to the North Quire Aisle to sign the register officially mak-

> **THE WORST OF AMERICA HAD CRAWLED OUT OF THE SHADOWY PLACES TO REMIND US OF THE HISTORY WE LIKE TO HIDE**

ing them one family joined forever even if the mountains should crumble to the sea. Bishop Curry, however, had made it clear in his address that they already were one family, that we all are.

Back in the States, we continued to wrestle with the legacy of the Royal African Company. **DOCKER NAZIS** marched with tiki torches chanting "blood and soil" at **THOMAS JEFFERSON'S** feet on the campus he designed. Children were torn from their parents and locked in cages. White House aides

> **NO ONE CAN SAVE US FROM THIS BUT OURSELVES AND THEN PUT US TO WORK**

flashed White Power hand signs at each other on TV. Squirrelly men accused of heinous acts against women were promoted and encouraged to do more harm.

The worst of America had crawled out of the shadowy places to remind us of the history we like to hide. **IDA B. WELLS-BARNETT,** who always kept her eye on the shadowy places, would remind us, "The way to right wrongs is to turn the light of truth upon them."

**ELLA BAKER** would tell us that no one can save us from this but ourselves and then put us to work.

## WE SHOULDN'T LOOK FOR LEADERS TO SAVE US. WE MAKE CHANGE TOGETHER. WE'RE STRONGER TOGETHER.

The million women marching in DC and millions of other marching all over the country had learned all over again what Baker taught us: we shouldn't look for leaders to save us. We make change together. We're stronger together.

The **2018 MIDTERM ELECTION** was a test of how truly organized White left-leaning women were, the ones who were still being viewed with suspicion for not turning out for Hillary Clinton when it mattered, helping to put the reality show host in the White House.

A **2017 SPECIAL ELECTION** in conservative Alabama had flipped a Republican seat to the Democrats, but this had largely been due to the legwork of Black women. Were a large enough number of White women going to overcome their discomfort with battling in the public sphere to make a difference in 2018?

Doors were knocked, calls were made, handmade postcards were sent. A record number of women ran for office, especially women of color, and a record number won. The House flipped Democratic, and for the first time over a hundred women would be Representatives. The brilliant Nancy Pelosi was poised to become Speaker again, and it looked like **MAXINE WATERS** was going to have subpoena powers.

**VOTER SUPPRESSION LAWS** that had sprung up in the wake of the Supreme Court's gutting of the **VOTING RIGHTS ACTS** were challenged, and the votes kept getting counted. Even better, total voter turnout had been the highest in fifty years.

The Public Sphere has been busted open.

Using our imperfect democracy, we the people will keep working toward that more perfect union.

# SUGGESTED ADDITIONAL READING

I am lucky enough to live in Cambridge, Massachusetts, with all of the academic resources a gal could possibly want. In the years I spent researching this book, and the years before that, when I was learning things that I didn't know I would eventually use in a book, I attended lectures and discussion groups, pored over archived academic papers, and held in my hands the treasures of Radcliffe's Schlesinger Library. I also read lots of books, and lots of parts of books. Although I'm not including a full list of my sources, here are some of the books that made the most impact on my thinking. They're a good start.

THIS WAY!

*Parlor Politics: In Which the Ladies of Washington Help Build a City and a Government* by Catherine Allgor

*Nellie Taft: The Unconventional First Lady of the Ragtime Era* by Carl Sferrazza Anthony

*Slaves in the Family* by Edward Ball

*The Firebrand and the First Lady: Portrait of a Friendship: Pauli Murray, Eleanor Roosevelt, and the Struggle for Social Justice* by Patricia Bell-Scott

*Unbuttoning America: A Biography of Peyton Place* by Ardis Cameron

*Love Across Color Lines: Ottilie Assing and Frederick Douglass* by Maria Diedrich

*Backlash: The Undeclared War Against American Women* by Susan Faludi

*Abigail Adams: A Writing Life* by Edith B. Gelles

*Ida: A Sword Among Lions* by Paula J. Giddings

*When and Where I Enter: The Impact of Black Women on Race and Sex in America* by Paula J. Giddings

*Sexual Revolution in Early America* by Richard Godbeer

*Other Powers: The Age of Suffrage, Spiritualism, and the Scandalous Victoria Woodhull* by Barbara Goldsmith

*The Hemingses of Monticello: An American Family* by Annette Gordon-Reed

*American Amnesia: Business, Government, and the Forgotten Roots of Our Prosperity* by Jacob S. Hacker and Paul Pierson

*A Stranger in the House* by Robert Hamburger

*On Account of Sex: The Politics of Women's Issues, 1945–1968* by Cynthia Ellen Harrison

*Doubt: A History: The Great Doubters and Their Legacy of Innovation from Socrates and Jesus to Thomas Jefferson and Emily Dickinson* by Jennifer Michael Hecht

*Declaration: The Nine Tumultuous Weeks When America Became Independent, May 1–July 4, 1776* by William Hogeland

*Labor of Love, Labor of Sorrow: Black Women, Work, and the Family from Slavery to the Present* by Jacqueline A. Jones

*Women and the Public Sphere in the Age of the French Revolution* by Joan B. Landes

*The Whites of Their Eyes: The Tea Party's Revolution and the Battle over American History* by Jill Lepore

*Who Cooked Adam Smith's Dinner? A Story About Women and Economics* by Katrine Marçal

*The Peabody Sisters: Three Women Who Ignited American Romanticism* by Megan Marshall

*At the Dark End of the Street: Black Women, Rape, and Resistance—A New History of the Civil Rights Movement from Rosa Parks to the Rise of Black Power* by Danielle L. McGuire

*The Good Girls Revolt: How the Women of Newsweek Sued Their Bosses and Changed the Workplace* by Lynn Povich

*Let the People In: The Life and Times of Ann Richards* by Jan Reid

*The Victorian Internet: The Remarkable Story of the Telegraph and the Nineteenth Century's On-line Pioneers* by Tom Standage

*Maria W. Stewart, America's First Black Woman Political Writer: Essays and Speeches* by Maria W. Stewart

*Big Girls Don't Cry: The Election That Changed Everything for American Women* by Rebecca Traister

*Domestic Manners of the Americans* by Frances Milton Trollope

*The Age of Homespun: Objects and Stories in the Creation of an American Myth* by Laurel Thatcher Ulrich

*Radical Sisters: Second-Wave Feminism and Black Liberation in Washington, D.C.* by Anne M. Valk

*Assassination Vacation* by Sarah Vowell

*A People's History of the United States* by Howard Zinn

# ACKNOWLEDGMENTS

First, I need to thank Sarah-Jane Stratford, who started this crazy journey with me. We had a grand time, didn't we?

Thanks to Judy Linden, my agent, for making this real, and everyone at Seal Press for making it a book.

Thank you always to the ladies who keep me from knocking people's hats off: Marti Epstein, Diana Fischer, Felicity Lufkin, and Susan Shelkrot. Thanks to Dahlia Lithwick and Rebecca Traister and especially to Lizzie Skurnick, my favorite haranguer. Thanks to Virginia Hefferenan for advising me not to go crazy. Thanks to Hillary Glatt Kwiatek, my canvassing comrade, who's been there for me at the other end of the intertubes for so long.

Tremendous thanks to my wonderful aunt, Joan Deaderick, for all the theology chit-chat and for being related to me. Thanks to my brother, Al Deaderick, for existing.

Thanks to Maria Antifonario for the space and the fancy-ass coffee, and to Kirsten Alexander for the Little Pink House. Thanks to Clover, NOCA Provisions, Starbucks, Bourbon Coffee for your tables and chairs and snacks. Thanks to John Bell, who is always faster than Google. Thanks to Radcliffe's Schlesinger Library and the Cambridge Public Library for existing.

Thanks to all the people whose patronage kept me going. I am humbled by how many there are. You make me feel like the richest gal in town.

Finally, thanks to Will Slotnick, who helped me admit that I wanted to write a book. I wrote one!

# ABOUT THE
# AUTHOR

**JEN DEADERICK** has written about women and citizenship for *The New York Times* as well as *Dame* and *The Huffington Post,* and has been featured in *Refinery 29, Boston Globe, Thrillest, The Atlantic, The Daily Beast, Globe & Mail,* and others. She is the founder of the popular Equal Rights Amendment page on Facebook and the #UseThe19th Twitter campaign. She and her kid live in Cambridge, Massachusetts, surrounded by hipster cafés and intellectuals.

# ABOUT THE
# ILLUSTRATOR

**RITA SAPUNOR** is a cartoonist and illustrator whose work has appeared in *New York* magazine, *Vice*, Spiralbound, Medium, *Linus* magazine, and the *RESIST* anthologies. Many of her comics are autobiographical and explore gender inequity, body positivity, friendship, and fashion. She publishes weekly long-form comics on Patreon.com/ritalately and single-panel gags on Instagram @ritalately. Rita is what many would call an "emerging artist," and she would like you to know that she is here to stay and compulsively refreshing her email. Contact her through ritasapunor.com.